# ON COMMON GROUND

## THE *Public* ART OF SPARTANBURG

PHOTOGRAPHY BY **CARROLL FOSTER**

First printing, October 2015

ISBN paperback: 978-1-938235-15-3

ISBN cloth: 978-1-938235-16-0

Editors: Lynne Blackman, Betsy Teter, and Aimee Wise

Project assistants: Sarah Baldwin and Sari Imber

Cover and interior design: Brandy Lindsey & The Graphics House

Proofreaders: Kailey Milks, Casey Patrick, Jan Scalisi, Sarah Tignor, and Holly Watters

Photography: Carroll Foster

Printed in China by Everbest through Four Colour Print Group

Library of Congress Cataloging-in-Publication Data available online at loc.gov

Publication of this book is funded in large part by the Johnson Collection of Spartanburg, SC

186 West Main Street
Spartanburg, SC 29306
hubcity.org

*For Nelly and Kurt Zimmerli*

# Dedication

Theirs is perhaps a daring that feels foreign in our modern world. Imagine arriving in the United States in 1956, without a command of the language, a support system, or much of a bankroll. It's a long journey across a wide sea from Switzerland to a New York City port and, later, to a small Southern city. As members of a greatest generation that defies national nomenclature, Nelly and Kurt Zimmerli did just that. They set out on a great adventure that has brought great reward to Spartanburg.

Armed with only a university diploma and two years' professional experience when he came to this country,

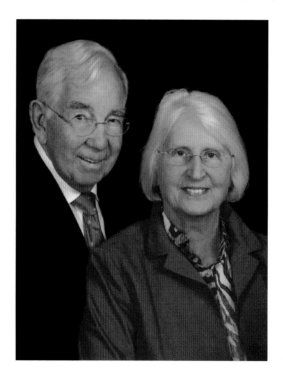

Kurt went door-to-door looking for work in his field. While he spoke no English, his clear talent as technical innovator spoke volumes to the employers who took a chance on the fledgling engineer. The tools of his trade occupied his drawing desk, along with a running list of English words he hoped to master. At night, he and his bride studied the vocabulary together, often while Kurt practiced metric conversions. Over time, Kurt's responsibilities and reputation grew, and he steadily moved up corporate ladders in respected Northeastern textile firms. Textiles eventually brought the Zimmerlis south, when, in 1969, Kurt established Zima Corporation in a commercial office park along I-85. The company would eventually

grow to become the largest textile and carpet wet-processing sales firm in the United States. Its economic contribution to Spartanburg is incalculable and continues today as Kusters Zima Corporation.

From the beginning, Nelly and Kurt embraced America—and especially Spartanburg—as their own. They gave time, energy, and treasure to our community in generous portion. They also imparted their European cultural sensibility to us: the tradition our shared community spaces should be alive with art of all forms, that visual art, music, and beauty should be democratic and daily experiences. Their fingerprints are everywhere—in pieces of publicly accessible art, in the landscaping and enhancement of public parks, in the advancement of fine arts in education. If your children have ever flocked to the sculpture of reading figures situated at the entrance of our library's headquarters or played in the interactive water fountain at Barnet Park, they have met Nelly and Kurt. If you've ever enjoyed a concert performed at the Zimmerli Amphitheater or admired the plaza design at Chapman Cultural Center, you know them, too. Their commitment and contributions have been formally recognized dozens of times at state and national levels. But their best reward is decidedly local: the cultural vibrancy of the place they chose as home, the place where they have dug deep and given much.

Nelly and Kurt Zimmerli are—for me and for many—the embodiment of good citizenship, benevolent stewardship, visionary leadership, and humble spirit. They are also beloved friends, whose presence and loyalty have enriched my family's life beyond measure. For these and countless other reasons, this book celebrating the art that enlivens Spartanburg's common ground is published in their honor.

**Susu Johnson**
May 2015

# Donors

*The Hub City Writers Project thanks its friends who made contributions in support of this book and other Hub City programs.*

## The Johnson Collection

Advance America

Patty and C. Mack Amick

Valerie and Bill Barnet

Judy and Brant Bynum

Carolina Alliance Bank

Stephen Colyer

Gail Ebert

Downtown Rotary Club

First Citizens Foundation

Elizabeth Fleming

Dorothy and Julian Josey

Jim and Patsy Hudgens

Mark and Sharon Koenig

Sara and Paul Lehner

Jeanie and Patrick O'Shaughnessy

The James Patterson Foundation

Phifer/Johnson Foundation

Romill Foundation

J M Smith Foundation

Betty Snow

Sally and Warwick Spencer

Michel and Eliot Stone

South Carolina Arts Commission

John Lane and Betsy Teter

Arkwright Foundation

Paula and Stan Baker

Carol and Jim Bradof

Susan Bridges

Beth Cecil

Sally and Jerry Cogan Jr.

Colonial Trust Company

Nancy Rainey Crowley

Donald L. Fowler

Mike and Nancy Henderson

Pam and Jay Kaplan

Tom and Nan McDaniel

Dwight and Liz Patterson

Anne and Gary Poliakoff

Billy Webster

Peter and Kathie Weisman

Adrienne Ables
Mitch and Sarah Allen
Winthrop and Heather Allen
Iris Amick
Monta and Kenneth Anthony
The Art Lounge
Tom and Ceci Arthur
Robert and Susan Atkins
Andrew Babb
Vic and Lynn Bailey
Don Bain
Harold L. Ballenger
Tom and Joan Barnet
Traci Barr
John and Laura Bauknight
Cyndi and David Beacham
Michael and Jessie Beaver
Charles and Christi Bebko
Victor and Linda Bilanchone
Lynne and Mark Blackman
Shirley Blaes
Ansley Boggs
June and Glen Boggs

Don and Mott Bramblett
Walter and Dolores Brice
Harold Bridges
Keland and Christi Brown
Bea Bruce
Duff Bruce
Myrna Bundy
Julia Burnett
Robert and Margaret Burnette
Dr. and Mrs. William W.
    Burns
Lynne and Bill Burton
Fritz and Lori Butehorn
Kathy and Marvin Cann
Renee Cariveau
Donna R. Cart
Peter Caster
Chuck White and Ruth Cate
Randall and Sally Chambers
Elizabeth Chapman
John and Lisa Chapman
Robert and Lacy Chapman
Nan and Tim Cleveland
Robert and Janeen Cochran
Bill and Sally Coker
Keith Shambaugh and Jay Coffman
Rick and Sue Conner
Randall and Mary Lynn Conway
Celia and Randy Cooksey
Pamela Coppes
Nancy and Paul Cote
Tom Moore Craig
Dick and Ann Crenshaw
John and Kirsten Cribb
Garrow and Chris Crowley
Betsy Cox and Mike Curtis
Ken and Rachel Deems
Fredrick B. Dent
Magruder Dent
Chris and Alice Dorrance
Arthur Farwell III and Elizabeth
    Drewry
Jean Dunbar
Kathy and Ray Dunleavy
Kirsten and Levon Eastin
Coleman Edmunds
Mr. and Mrs. William C. Elston
Edwin Epps
Jennifer and Alex Evins
Andy and Lynne Falatok
Lisa Anderson and John Featherston
Kerry and Mark Ferguson

George Fields Jr.
First South Bank
Russel and Susan Floyd
J.F. Floyd Mortuary
Caleb and Delie Fort
Joan Foss
Steve and Abby Fowler
Elaine T. Freeman
Larry and Betsy Fritz
Dr. Ron Fulbright
J. Sidney and Lenna Fulmer
Carol Young Gallagher
Joan Gibson
Jan and Larry Goldstein
Barney and Elaine Gosnell
Laura and John Gramling
Carter Graves
Andrew Green
Margaret and Chip Green
Lucy Grier
John Morton and Susan Griswold
Jim and Kay Gross
Roger and Marianna
    Habisreutinger
Lee and Kitty Hagglund
Mary Hamilton
Benjy and Tanya Hamm
Al and Anita Hammerbeck
Bob and Barbara Hammett
Tom and Tracy Hannah
Robert and Carolyn Harbison III
Darryl Harmon
John and Lou Ann Harrill Jr.
Rodney and Marie Harley
Peyton and Michele Harvey
Jonathan Haupt
Mark Hayes
David and Rita Heatherly
Gary and Carmela Henderson
Peggy and David Henderson
Laura Beeson Henthorn
Patty Ann and Marvin Hevener
Stephanie Highsmith
Hayne Hipp Foundation
Charlie Hodge
Holly Hoenig
Myrta and David Holt
Doug and Marilyn Hubbell
Mr. and Mrs. Kenneth R. Huckaby
Elsa Hudson
Woody and Carol Hughes
Max Hyde

David and Harriet Ike
Susan Irwin
Sadie Jackson
William A. James
Joyce P. Jeffers
Chris and Manya Jennings
Geordy and Carter Johnson
Stewart and Ann Johnson
Wallace Eppes Johnson
Betsy and Charles Jones
Frannie Jordan
Marshall and Katie Jordan
Daniel and Vivian Kahrs
Peggy and Greg Karpick
James Karegeannes
Ann J. Kelly
Nancy Kenney
Thomas and Mimi Killoren
Beverly Knight
Bert and Ruth Knight
John M. Kohler Jr.
Connie Kunak
Mary Jane and Cecil Lanford
Jack and Kay Lawrence
Janice and Wood Lay
Joe and Ruth Lesesne
Eric and Brandy Lindsey
Francie and Lindsay Little
George and Frances Loudon
Brownlee and Julie Lowry
Robert and Nancy Lyon
Ed and Suzan Mabry
Joe and Keysie Maddox
Gayle Magruder
Kari and Phillip Mailloux
Nancy Mandlove
Zerno Martin
Matt Matthews
Dan and Kit Maultsby
Jim Mayo
Bill and Wendy Mayrose
John and Stacy McBride
Cathy McCabe
Ellen Goldey and Byron McCane
David McCarthy
Kay McClure
Judy McCravy
Betsy McGehee
Fayssoux McLean
Ed and Gail Medlin
Larry E. Milan
Don and Mary Miles

Boyce and Carole Miller
Weston Milliken
Deb and George Minot
Karen and Bob Mitchell
Sam and Dennis Mitchell
John and Belton Montgomery
Laura Montgomery
Charles and Paula Morgan
Carlin and Sander Morrison
Susan Tekulve and Rock Mulkey
Susan Myers
Kam and Emily Neely
Charles Morgan
Margaret and George Nixon
Walter and Susan Novak
Cecile and Chris Nowatka
Corry and Amy Oakes
Jane and James Ovenden
Janice and Alva Pack
Geneva F. Padgett
Louise and W. Keith Parris
Steve and Penni Patton
Sarah Chambers and Becky Pennell
Carolyn Pennell
Richard Pennell
Mr. and Mrs. Edward P. Perrin
Terry Plumb
Andrew and Mary Poliakoff
John and Lynne Poole
Jan and Sara Lynn Postma Jr.
Harold B. Powell
Perrin and Kay Powell
Elizabeth and W.O. Pressley Jr.
Betty Price
Philip and Frances Racine
Eileen Rampey
Karen Randall
Allison and John Ratterree
Beverly Reed
Alix Refshauge
Tracy Regan
John Renfro
Rob Rhoden and Laura Barbas-
    Rhoden
Naomi Richardson
Ricky and Betsy Richardson
Anna Rickell
Robert and Nancy Riehle
Rose Mary Ritchie
Elisabeth and Regis Robe
Martial and Amy Robichaud
Bertice Robinson

Gail Rodgers
Renee Romberger
Matt Johnson and Kim Rostan
J.B. Russell Construction Co.
Steve and Elena Rush
Ellen Rutter
Mary Ann and Olin Sansbury
Kaye Savage
Susan Schneider
Garrett and Cathy Scott
Ruta Sepetys
Steve and Judy Sieg
Caroline and Ron Smith
Danny and Becky Smith
Emily Louise Smith
Lee and James Snell Jr.
Southeastern Printing
Eugene and Rita Spiess
Hank and Marla Steinberg
Brad Steinecke
B. G. and Sandra Stephens
Dianne Vecchio and John Stockwell
Tammy and David Stokes
Phillip Stone
Brenda and Ed Story
Margaret Sullivan
Travis Sutton
Robert and Christine Swager
Pat Tatham
Nancy P. Taylor
Frank Thies III
Ray E. Thompson, Sr.
Aaron and Kim Toler
Deno Trakas
Mark and Meredith Van Geison
Judith Waddell
Chuck Reback and Melissa Walker
Samantha Wallace
Bill and Winnie Walsh
Lawrence and Jerri Warren
Holly and Adair Watters
Mary Ellen Wegrzyn
Brian Welsch
Dave and Linda Whisnant
Karen and John B. White, Jr.
Alanna and Don Wildman
William and Floride Willard
Dennis and Anne Marie Wiseman
Diane Smock and Brad Wyche
Bob and Carolyn Wynn
Steve and Charlotte Zides
Suzanne and Jon Zoole

## INTRODUCTION
# *The Johnson Collection*

Southerners have always had a vested interest in place. Whether that place is a family plot of land handed down for generations or a quintessential small-town square, a sense of place—and, perhaps even more so, pride of place—seems to be a part of our regional DNA. This proclivity started with royal land grants, endured a civil war and its aftermath, and survives today in the face of urban sprawl and an increasing influx of folks "from off" in search of warmer temperatures and Southern charm. Throughout this history, our public places have served as our "company clothes," broadcasting our communities' victories and values, of both the historic and personal variety, to neighbors and visitors alike. With monuments and memorials, statuary and gardens, and even unsanctioned expressions like graffiti, public art functions as a barometer of taste, an aesthetic clue to civic character.

As a strategic initiative, public art in the United States is a relatively new concept. While the tradition spans centuries in Europe, the first formal community effort in this country occurred in 1872 when a group of Philadelphians formed the Fairmount Park Art Association, "the first non-profit organization focused on integrating public art and urban planning."[1] The association's inaugural effort resulted in the placement of classical sculpture along the scenic Benjamin Franklin Parkway. The campaign was a success, but not without controversy—a perennial hallmark of public art initiatives. While audiences were generally delighted, there were residents who deemed the female statues' clinging drapes too suggestive. Regardless, the association thrived and continues today as the Association for Public Art.

Nearly 150 years later, public art is far more than "a hero on a horse anymore."[2] We can thank Franklin D. Roosevelt's New Deal for that. His Depression-born Federal Art Project and Works Progress Administration put professional artists to work and put art

in post offices, libraries, and municipal buildings across the country. Just a few decades later, his Democratic descendant John F. Kennedy revived the notion that government bore some onus for collective creativity, writing that it "surely has a significant part to play in helping establish the conditions under which art can flourish."[3] Could either leader have envisioned the state of public art in 2015? Today, it is color and concept, volume and form, multi-dimensional and multi-media, political and universal, permanent and ephemeral. It is anywhere and everywhere, commissioned and co-opted, topical and timeless. Whatever public art is or isn't in any particular place, it is always a source of community conversation—and the artists who create it wouldn't have it any other way.

Marc Pally, a California-based artist and public art consultant, has described public art as a "rupture in pedestrian life." At its best, public art offers a cultural intervention in our everyday paths—a moment for pause, reflection, remembrance, rejoicing, or, in some cases, outrage. We can love it or hate it, but if, in the end, a piece of public art has fired our synapses and shifted our gaze, it has done its job. Spartanburg has long embraced public art, as unique individual expressions and as a civic concept. We love where we live, and we let the world know it in paint, bronze, granite, steel, grass, water, and wood. Federal agencies and private corporations often base big-dollar decisions on how communities convey their spirit on common ground. Spartanburg's shared spaces are alive with art that invites, informs, inquires, and—thankfully—multiplies.

—LYNNE BLACKMAN

(Endnotes)

1   Cher Krause Knight, *Public Art: Theory, Practice and Populism* (Maiden, MA: Blackwell Publishing, 2008), 2.

2   Arlene Raven, *Art in the Public Interest* (Ann Arbor: University of Michigan Research Press, 1989), 1.

3   *Public Papers of the Presidents of the United States: John F. Kennedy* (Washington, DC: US Government Printing Office, 1963), 246.

*Whatever public art is or isn't in any particular place, it is always a source of community conversation.*

# JOHN QUINCY ADAMS WARD & EDWARD BRICKELL WHITE
## *Daniel Morgan Monument*
Morgan Square

*John Quincy Adams Ward (1830-1910) was a founder of the National Sculpture Society and served as president of the National Academy of Design. A resident of New York City, he was the sculptor of* The Indian Hunter, *as well as several other pieces in Central Park. He also assisted Henry Kirke Brown (1814-1886) with the equestrian statue* George Washington *in New York's Union Square.*

*A native South Carolinian, Edward Brickell White (1806-1882) was an American architect who specialized in Gothic American architecture. He designed several landmark churches in Charleston, South Carolina, as well as Trinity Episcopal Church (now Cathedral) in the state's capital of Columbia.*

By the late 1870s, much of the bitter discord in national politics following the Civil War and Reconstruction was subsiding, and all factions could look to the centennial of the American Revolution as a common rallying point. Two organizations, the town council of Spartanburg and the Washington Light Infantry of Charleston, appointed a committee to organize an appropriate event and memorial to celebrate the centennial of the great victory at Cowpens. The Cowpens Centennial Committee achieved a major feat—securing approval and funding from both Congress and all 13 original colonies, the first such cooperative effort since the Civil War.

Noting that the true centennial in January was prone to bad weather and that the battlefield was remote and prone to vandalism, the committee chose to hold the celebration on the public square in Spartanburg on May 11, 1881. John Quincy Adams Ward was selected to design and execute the bronze statue of General Daniel Morgan, while Edward Brickell White designed the granite base and column upon which the statue stands. The event at which it was unveiled and dedicated drew some 20,000 people to the little town of Spartanburg, whose resident population only numbered about 3,000. Among the guests were many governors, senators, and congressmen. President James Garfield, who was to deliver an address, was detained in Washington at the last minute.

Although the monument itself has not been altered, its location and context have changed several times through the years. It was originally surrounded by a short wrought-iron fence, and around the turn of the century, two Confederate naval cannons were added to the monument's northern and southern faces. The cannons were removed and melted down during a World War II scrap metal drive. In 1960, a new traffic layout necessitated the monument's removal from its original location to the square's far eastern end. Controversially, the statue was turned so that he faced the square, with his back turned towards Cowpens. In 2005, another redesign of the square brought the monument back to its original location.

—BRAD STEINECKE, LOCAL HISTORY ARCHIVIST, SPARTANBURG COUNTY PUBLIC LIBRARIES

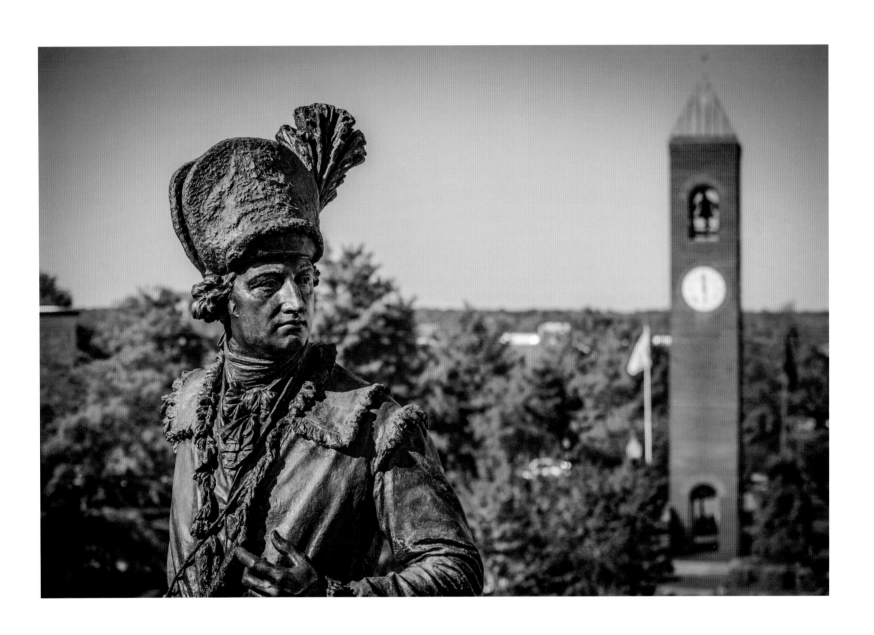

# BAILEY SZUSTAK
## *Kratos*

Converse College, Milliken Fine Arts Building

*Bailey Szustak is a Spartanburg native and a proud alumna of Converse College. As an artist, she works primarily in metal sculpture, with particular interest in scrap metal and welding. She is also a philosopher-in-training and recently completed a master's degree at Texas Tech University in Lubbock. She plans to continue on to a PhD program and hopes to eventually teach.*

When I was studying art at Converse College, Professor Mac Boggs suggested that I explore welding. He had a real knack for sensing where and when his students needed encouragement—or even a gentle push. He was right about me and welding; I fell in love with it. When I'm asked why I chose horses as a subject, I like to say it's because I never got a pony for Christmas. That's the short answer. In truth, I was really drawn to the challenge and scale of portraying these animals. Horses have muscles and weight and power—and yet are very graceful. After I completed my first horse, Mac pushed me a little bit more by saying I should make a life-sized version.

I started with sketches and blueprints, and then began combing Spartanburg's scrapyards for components—road signs, car remnants, pieces with a particular shape. I started out with one large horse. Since I needed to do a senior show, everyone encouraged me to create a herd. In the end there were seven horses. All told, they took 18 months to create; for six of those months I basically lived in the sculpture studio, only coming out for classes, meals, and sleep.

The response has been gratifying. When the herd was first displayed on Converse's front lawn, I would sit out there and watch people drive by, stop, back up, and then get out of their cars to look more closely. I especially loved the children's reactions—the horses brought out a lot of laughter and play.

—BAILEY SZUSTAK

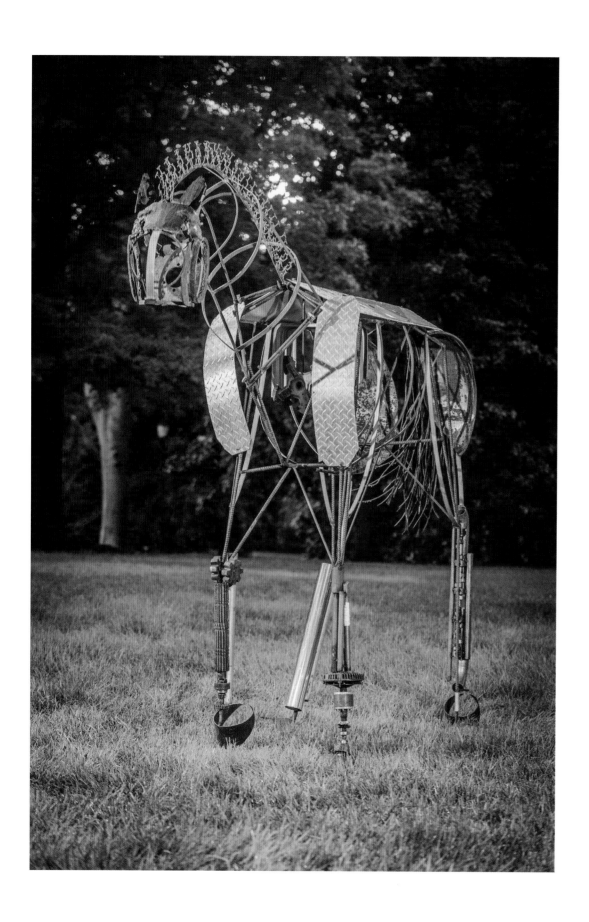

*Thousands of Gary Price sculptures are in public and private collections around the world—in homes, galleries, museums, cities, universities, and corporations. A member of the National Sculpture Society, he was commissioned to design the 300-foot Statue of Responsibility on the West Coast, which will be a companion to the Statue of Liberty. He lives in Mapleton, Utah, and he and his wife, Leesa, have nine children.*

# GARY LEE PRICE
## *Einstein*
340 East Main Street

Other than Einstein's eccentricities and ability to think out of the box, his quote that has won great favor with me for many years is, "Imagination is more important than knowledge." I kept thinking to myself that I must memorialize a guy that had such vision.

I have always been excited by the sheer visual richness of Einstein: his hair, facial features, and casual attire. I wanted to portray this in a very approachable, inviting, come-have-a-chat-with-a-genius kind of gesture. In studying Einstein's life, I was equally impressed with his efforts and desire to create a world of peace and understanding in spite of the horrendous happenings of his era.

As he relaxes in the park, who knows what is really going on in his mind as he gazes out on and ponders our universe?

—GARY LEE PRICE

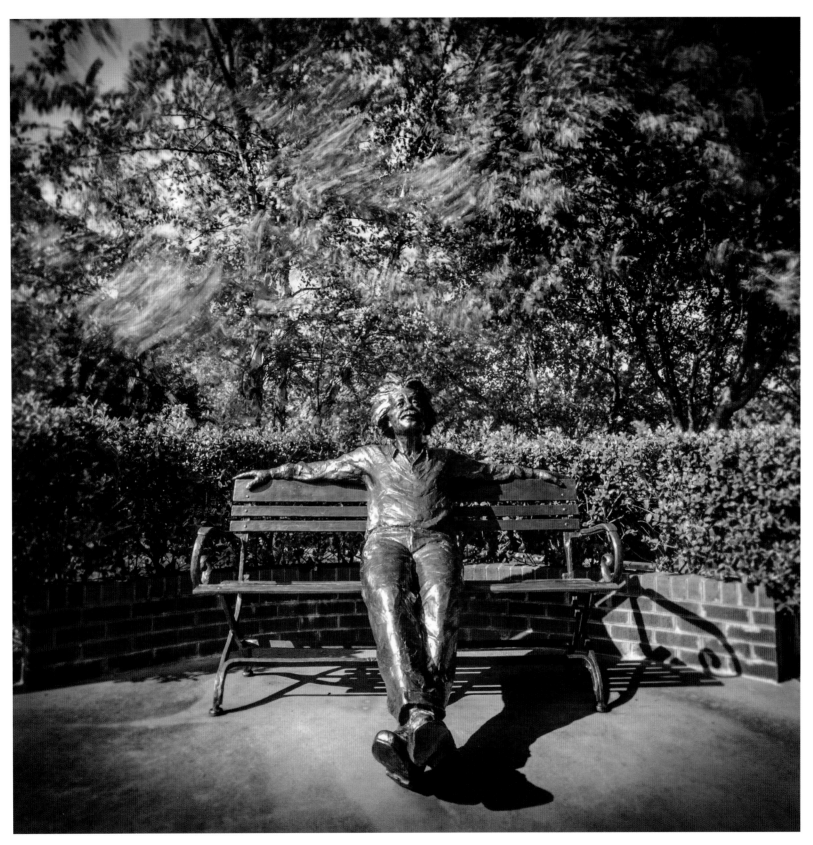

*First Lieutenant Jordan Clayton, the former director of HUB–BUB's "Love Where You Live" campaign, is currently the Rear Detachment Company Commander for the 366th Chemical, Biological, Radiological, and Nuclear (CBRN) Company based out of Savannah, Georgia, as well as the primary Company Commander for the 414th CBRN Company based out of Orangeburg and Greenville, South Carolina, in charge of coordinating the employment, training, and readiness of more than 230 Army soldiers across the Southeast.*

## HUB-BUB ARTISTS
# *Love Where You Live*
Corner of West Main and South Spring Streets

This was an idea that Cate Ryba and Russell Bannan of HUB-BUB had, and it just spiraled into a big community effort. Russell designed it based on the famous Sixth Street Mural in Austin, Texas. We had lots of suggestions for logos to be included, and there were about 20 drafts of the design. The mural was funded by downtown businesses, and we raised all the funding in just a little over two weeks.

One night, we projected the image on the white wall and did the tracing. Then it took four days and nights of painting. There was a cold snap during the process—one night it even got down in the 20s and it was misting, so it was really raw. People were great about offering encouragement and assistance in a lot of different ways. Jeremy Kemp, a local sign painter, provided a lot of advice, and the painters included Aimee Wise, Eli Blaško, Lily Knights, Cate, Russell, and plenty of others who just stopped by, like local businessman Andrew Babb. My dad, Steve Clayton, was with us every day, running errands, building the scaffolding, and making sure we had everything we needed. Andrea Marmolino brought us food from Renato's, and Geordy Johnson brought us beer. One guy, who had just moved here from out of town, set up and made us coffee on the spot one afternoon.

In the end, we created a destination in downtown Spartanburg—a place where people can take pictures and love where they live.

—JORDAN CLAYTON

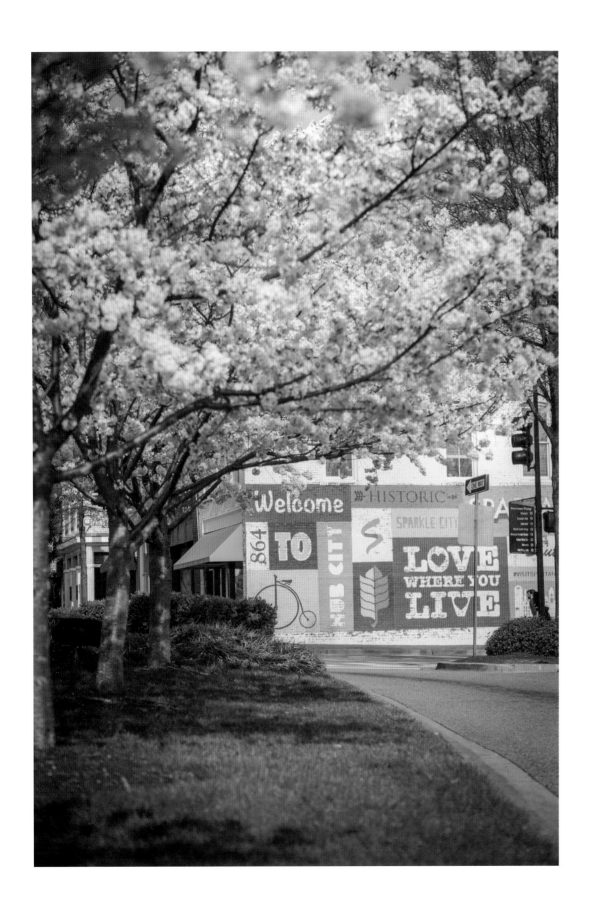

*A Spartanburg native with an MFA in sculpture from Clemson University, Winston A. Wingo has had more than 40 one-person art exhibits, and his work has appeared in 200 group competitions and invitationals.*

*As an art educator, he has taught in the public school system and several colleges in South Carolina. His sculpture commissions include a bust of Martin Luther King, Jr. for the city of Spartanburg and a bronze casting for the South Carolina Governor's School for the Arts and Humanities. He currently lives and has a studio in Spartanburg where he teaches and mentors young artists.*

# WINSTON WINGO
## *Back of the College*
Wofford College, Gibbs Stadium

With the expansion of the Wofford College campus in 1996, an African-American community historically known as "Back of the College" was removed. There once was a strong African-American community there, and it was pretty much torn down completely. Wofford contacted me to create a monument to represent that community.

The images in the piece depict black institutions as well as key African-American educators, one of whom was Louvenia Barksdale, who lived on Evins Street. You also can see in the piece the old Cumming Street School, one of the first African-American public schools in Spartanburg. The black church is represented, as well as Wofford's Old Main building.

To make this piece, I created a series of drawings; from that I crafted a clay sculpture to make a wax mold. The mold was sent to a foundry in upstate New York to cast it in bronze. When it came back, I did the chasing and finishing in the patina. The reaction has been very positive. I think it has been one of the most important monuments that I have created.

—WINSTON WINGO

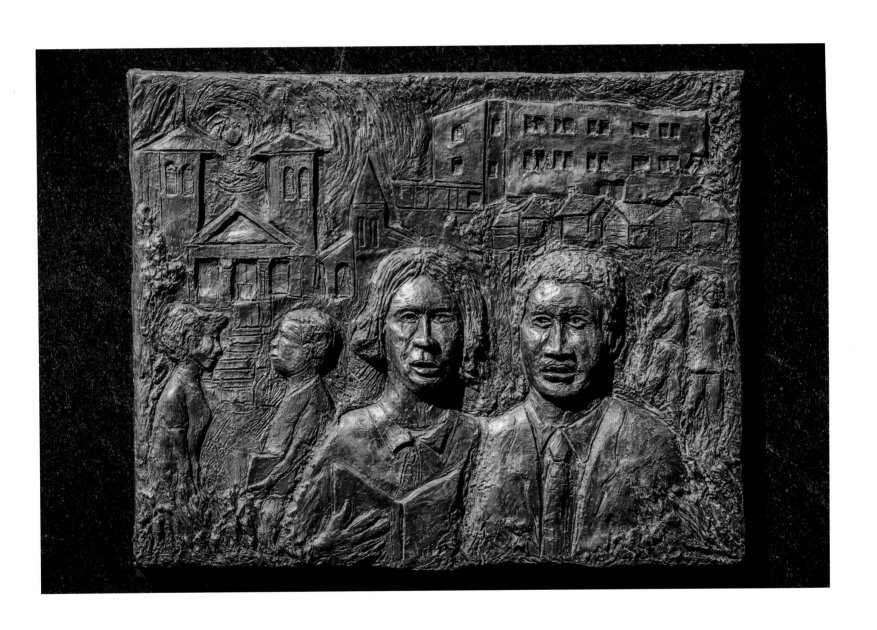

*Vivianne Lee Carey was born in Millville, New Jersey, in 1959 and lives in Spartanburg. She is a sculptor who works primarily in metal and glass. Her work is featured on the Cottonwood Trail, at Hatcher Garden, at Happy Hollow Park, and in private collections. Carey has exhibited her work at the Chapman Cultural Center, Converse College, Winthrop University, and other regional venues. In 1981, she received her BFA from Converse College and is pursuing an MFA at Winthrop University in Rock Hill. She is an adjunct art professor at Converse and was an art teacher at St. Paul the Apostle Catholic School for eight years.*

# VIVIANNE CAREY
## *Magnified*
Happy Hollow Park, Glendalyn Avenue

This sculpture, *Magnified*, and another at the Cottonwood Trail, *Ascension*, were commissioned by friends and family of Gladys Kearse Carey and Janet Falzarano White, respectively. I think that the love and determination of these donors to give a memorial of art to the community to honor these two women inspired me the most. These works are powerful metaphors of the lives of the exemplary women that they commemorate.

For *Magnified*, the children of Gladys Kearse Carey sought a strong, cheerful image to honor their mother. It is an enlarged (hence the name of the sculpture) traditional, asymmetrical floral design. The fiery color combination of the three gerbera daisies is its greatest strength, while the thin linear grasses bring life to the sculpture, and the humongous leaf shapes emphasize the bright floral components. While I was sitting on the ground, tired and patting cold concrete into shape for *Magnified*, people would stop and shout out the car windows that they loved it, and it made their day to ride by it. That was special.

At the age of 33, I had a powerful spiritual conversion experience that continues to influence my work. The materials and formats are constantly changing, but the underlying foundation continues to be the metaphorical exploration of the tenuous universal conditions that face humanity between grace and disgrace, birth, death, and rebirth, and good and evil within a regenerative perspective.

—VIVIANNE CAREY

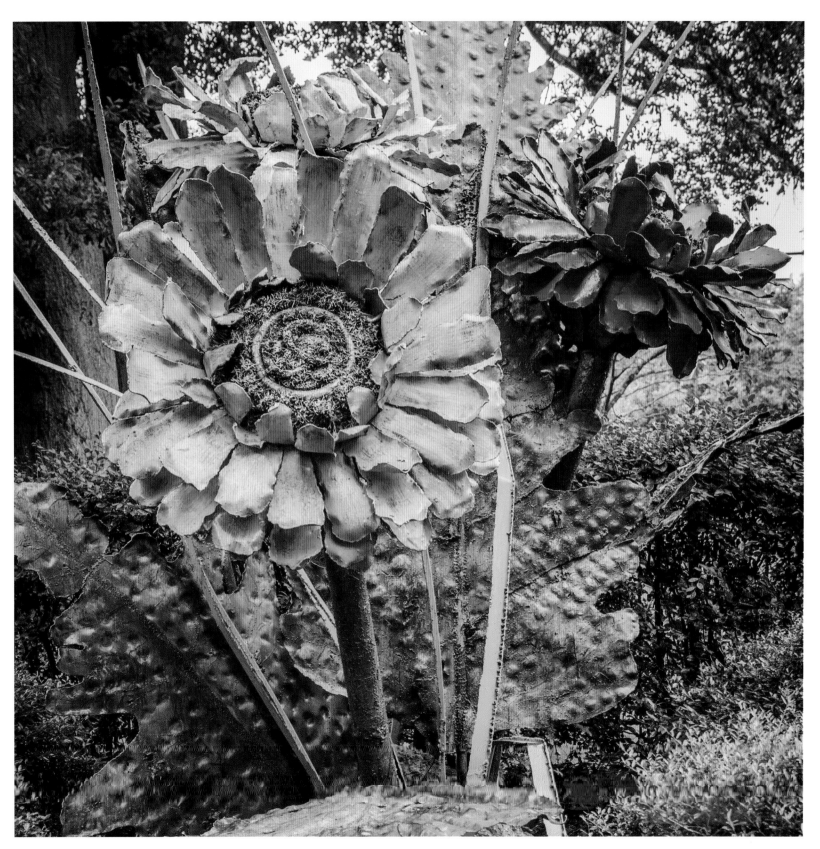

# DENNIS SMITH
## *Stargazers*
Meeting Street Academy, 201 East Broad Street

*For the past 40 years, Dennis Smith's work and presence have been a driving force in sculpture in the United States. His representations of families, mothers, and children in sculpture have become a national treasure. His work is located in hundreds of public and private collections, in museums, and public squares throughout the world, including the town center of Vail, Colorado; the Children's Hospital in New Orleans, Louisiana; and the San Antonio (Texas) Zoo. His impressionistic style captures his exuberance for life and embodies his passion for transcendence— expressed through the spontaneity of children, reflections of the past, and hopes for the future. Smith lives and works in Alpine, Utah.*

Contemporary art circles often think that the image of parent and child is passé and not relevant to current art themes. However, the parent theme is as relevant today as it has ever been. I believe, however, that the topic is timeless, and I offer this refreshing piece as evidence that a loving familial relationship is always germane—in life and art. The grandfather and grandchild represent a stretch of three generations, united in their search for a glimmer of light from the evening's first star. Together they are reminded of the universe's expanse and the possibility of worlds without number.

I feel that art in public space enhances not only the beauty of an area, but draws attention to art in general. In any European town, citizens go to great lengths to preserve public art such as fountains, statues, paintings, and historic buildings, as art circles in Europe generally recognize the value and need for beauty available to the general public. Within the last 20 to 30 years in the United States, there has been a growing appreciation of art and an emphasis on making beauty available to the public. Competitions for artists to create a piece to be placed in public areas have triggered an increased awareness of art.

—DENNIS SMITH

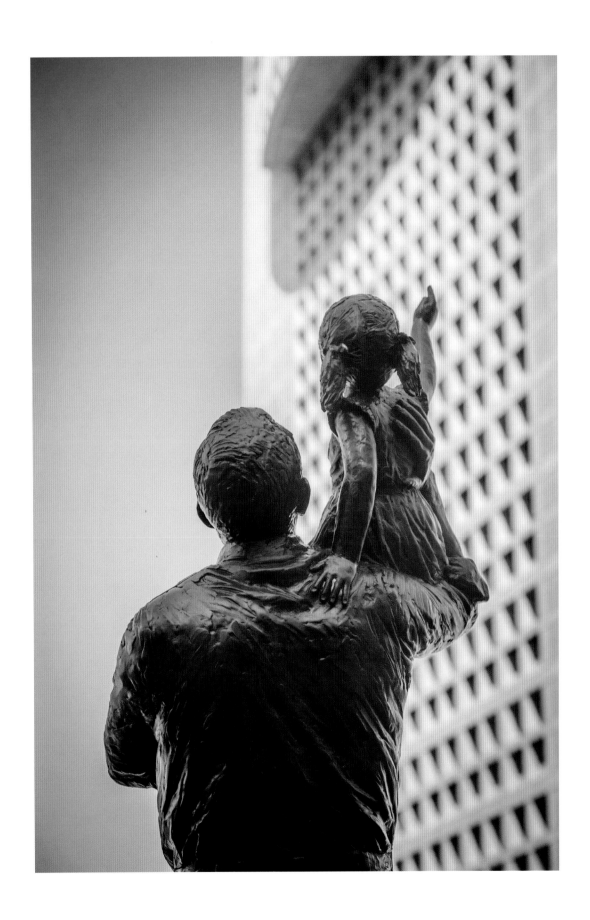

# HANNA JUBRAN
## *Big Red One*
University of South Carolina Upstate, Campus Life Center

*Hanna Jubran is an internationally acclaimed Palestinian sculptor born in Jish, an ancient city in the upper Galilee. His work has been exhibited in North America, Europe, the Middle East, Asia, and Latin and South America. He received his MFA in sculpture from the University of Wisconsin–Milwaukee and is currently a sculpture professor and sculpture area coordinator at East Carolina University in Greenville, North Carolina.*

*Big Red One* is from a series of sculptures that I have been creating for the past 20 years. My interest in the four elements and nature gave me the opportunity to explore one of the most interesting forces: that moment of separation, escape, and attraction toward each other—where the landscape moves all the time so that viewpoints constantly change, and passages open and close. The relationship of those forms complements the positive and negative space the sculpture contains. I am conscious of the impact these sculptures will carry. The viewer will regard the work as a contribution to contemporary sculpture because of the visual weight and aesthetic qualities.

The placement of the sculpture on the grounds of the university identifies it as a unique piece for the students and faculty. Although this sculpture is painted specific colors, those change depending on the time of day and season. It also changes as you move around the sculpture and view its relation to the surrounding architecture and landscape. Between nature and the sculpture, I am condensing time and space. They are ever-changing.

Large outdoor sculpture becomes a part of the environment and landscape, so that the public can enjoy the work and see the changes throughout the season.

—HANNA JUBRAN

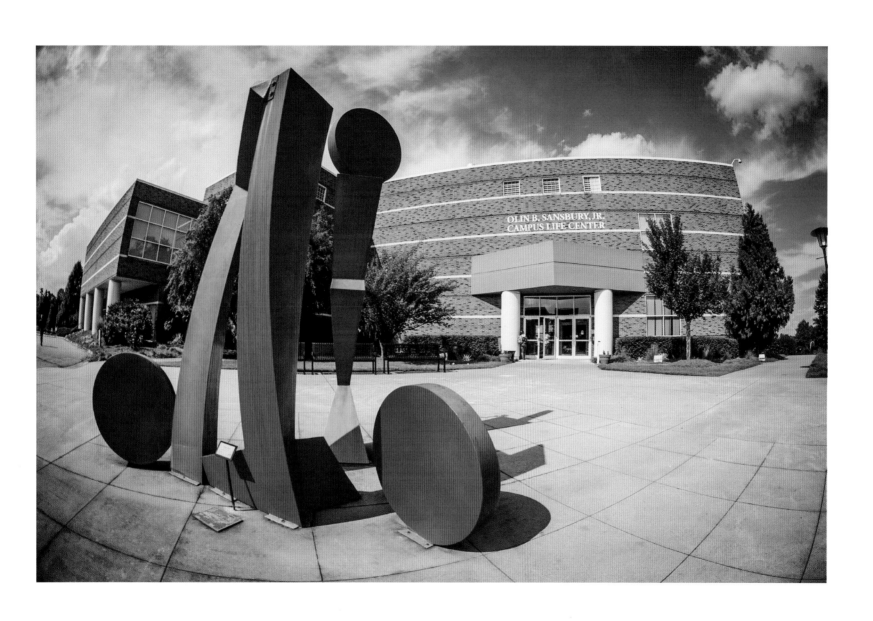

## PAUL SIRES
### *Cotton Leaf*
Morgan Square

*A Charlotte sculptor, Jonathan Paul Sires is the former director of Clayworks at Spirit Square in Charlotte, North Carolina. He received his MFA from the Cranbrook Academy of Art in Bloomington, Indiana, and his BFA from Kent State University in Kent, Ohio. Sires has exhibited his work at a number of museums, including the Mint Museum of Art in Charlotte, North Carolina, the University of New Mexico Art Museum in Albuquerque, the Cleveland (Ohio) Museum of Art, and the Pallazzo Venezia in Rome, Italy. He is the recipient of a National Endowment for the Arts Fellowship, the North Carolina Visual Artist Fellowship, and the Ohio Individual Artist Fellowship.*

*Cotton Leaf* is made of three different types of granite that have been cut and fit together. The three parts create a flat surface that has then been carved in bas-relief, keeping in mind the concepts of Time, Weight, Growth, and Balance. Its strength comes from the poetry and balance of the carving, and the contrast of the stones to each other and the darker brick pavement. This careful geometry is also illustated in the work by how the parts fit together and mirror the form of a cotton boll as it is fruiting and splitting open to reveal the cotton fibers. Of course, the choice of the cotton leaf is a reflection on the agricultural history of this region. I believe that public art should help create a sense of place and reflect the journey of the community that it engages.

—PAUL SIRES

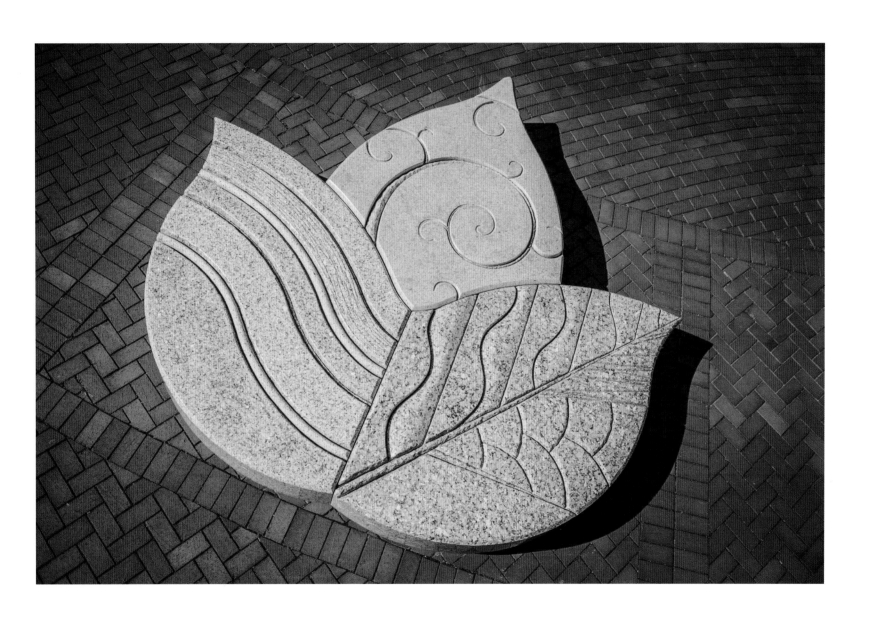

*This sculpture was donated to the Spartanburg County Public Libraries by Nelly and Kurt Zimmerli.*

*Thousands of Gary Price sculptures are in public and private collections around the world—in homes, galleries, museums, cities, universities, and corporations. A member of the National Sculpture Society, he was commissioned to design the 300-foot Statue of Responsibility on the West Coast, which will be a companion to the Statue of Liberty. He lives in Mapleton, Utah, and he and his wife, Leesa, have nine children.*

# GARY LEE PRICE
## *Story Time*

Spartanburg County Public Libraries Headquarters, 151 South Church Street

Many times at our home, the poor television gets ignored because of so many good books. We like to dive right in! Every once in a while, maybe every few days or so, we come up for air and turn on the news just to make sure that the world still exists and that everything is on proper course. Then we buzz to the bookstore, buy a stack, come back home, and dive in again. Poor television...

These pieces represent the joy that comes from being with those you love and immersing yourself in a great story. These two children are bent over their books, anxious to turn the page, ready to explore.

—GARY LEE PRICE

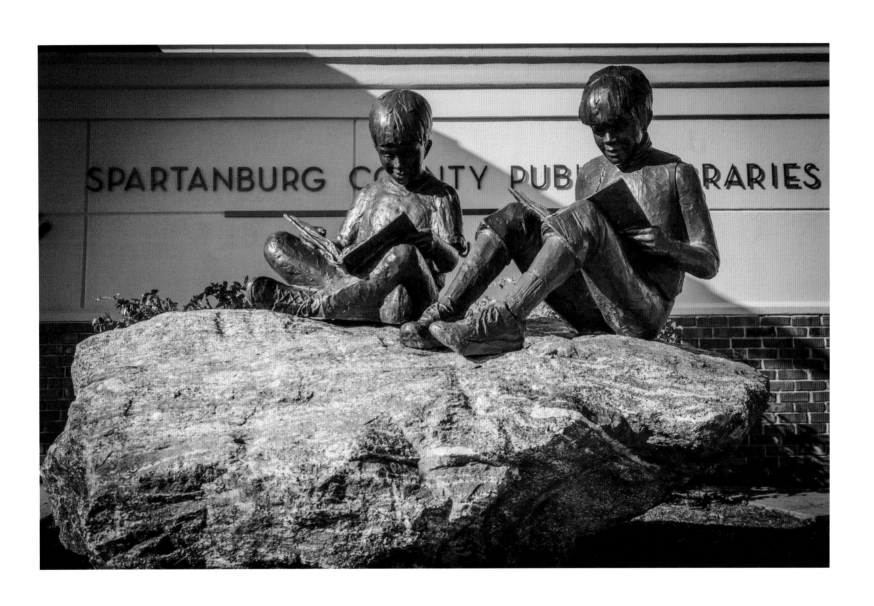

## BERRY BATE
## *Peach Tree*
435 East Main Street

*Berry Bate is a graduate of Converse College who has created more than 2,000 pieces of sculpture and ironworks for private residences, collectors, public places, and colleges during her 35-year art career. She has created work for the Biltmore Estate, the Billy Graham Training Center at the Cove, and the Grove Park Inn, all in Asheville, North Carolina, as well as for Chimney Rock State Park and many other places. She also served as a consultant on the restoration of the Statue of Liberty. She is the founder of Asheville Ironworks and operates Sculpture by Berry Bate in Asheville.*

When I was asked by the Graffiti Foundation to create a piece that represented Spartanburg, I started to look at major influences on the area. Upon discovering that peaches were a major crop, I designed a full-size peach tree, after going into the orchards and studying the trees. We created the trunk system, over 2,000 leaves, each with its own personality, and peaches, all out of iron. The sculpture took many months to build. My greatest delight was when we forklifted the sculpture out of the moving van, and a bird lit onto it immediately.

I felt I had done what I meant to do, which was to create the spirit of a living tree.

The most important tools in my studio are my many types of hammers. I use a technique called repousse; I heat the metal, and then bring it over to a log and use repousse hammers to form each piece until it says, "I am alive." I let the piece of metal speak with its own spirit.

—BERRY BATE

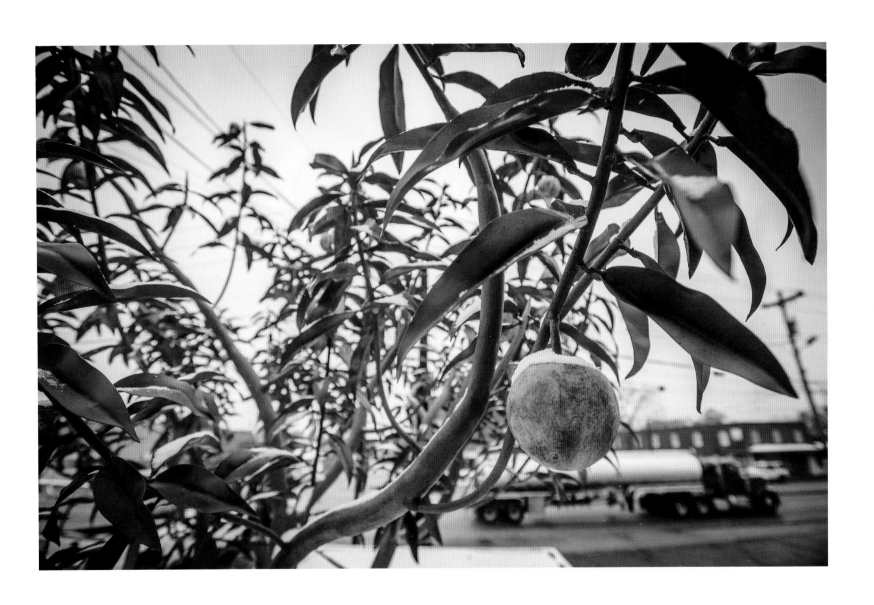

## MOLLY ROSE FREEMAN
### *Untitled*

Cribbs Kitchen/RJ Rockers, 226 West Main Street

*Molly Rose Freeman earned her high school diploma in visual arts from the University of North Carolina School of the Arts in Winston-Salem and her BA in creative writing from the University of North Carolina at Asheville. She spent several years working from a studio in Asheville's River Arts District before moving to Atlanta, Georgia, in 2013. When creating public art, she "seeks out the distinctive pulse of each space in the service of activating its spiritually transformative properties." Freeman was the 2014-2015 Walthall Artist Fellow through Wonderroot.*

My raw material comes from looking around and constantly gathering visual information. I construct patterns based on the idea that everything is connected, so for me, there is no distinction between things that are inspirational and things that are mundane—anything can be an inspiration in the right context.

The stimulus for this particular piece came from the logo for the Grain District, information about the nonprofits that RJ Rockers supports (two of which involve bicycles), and basic information about the brewery itself. I think these elements were churning around when I was working on my sketch for the wall, and what came out was a perfect melding of all of these things. It's not a literal representation, but this piece is definitely influenced by the space that it's in—it wouldn't feel at home anywhere else.

When I look at a work of public art as a viewer, I want to have a visceral reaction to what I'm seeing. I want to have more questions than answers; I want magic and mystery. As an artist, I want this same experience when I'm creating a work. I am surprised by almost every piece I make, and I hope that sense of wonder comes through. I don't have something specific in mind that I want the viewers to feel, I just want them to sense something. And if a community can have a collective experience, then the work becomes all the more powerful.

—MOLLY ROSE FREEMAN

# ELLIOT OFFNER
## *Maria Mitchell*
Converse College, Phifer Science Hall

*Elliot Offner (1931–2010) was a sculptor, painter, and printmaker, and a long-time professor at Smith College in Northampton, Massachusetts. He was president of the National Sculpture Society for three years, and his work can be found in public and private collections throughout the world, including the Brooklyn (New York) Museum and the Smithsonian Institution's Hirshhorn Museum and Sculpture Garden in Washington, D.C. He and his wife are the namesakes for the Elliot and Rosemary Offner Sculpture Learning and Research Center at Brookgreen Gardens at Pawley's Island, South Carolina. This sculpture depicts Maria Mitchell (1818–1889), the first female professional astronomer.*

My research on Maria has been fairly extensive. I have been through her archive at Vassar College as well as her birthplace here on Nantucket, and I have seen and read much of the published material about her. Her legacy to the nation of scientific achievement, brilliant thought and writings, and early feminism is amazing.

Alas, Maria did not like to be photographed and there is a paucity of visual material. I have had prints made from all the available original negatives, most of which are not in focus. There are paintings, some sculpture, which reveal rather masculine features. But the most challenging aspect of representing her results from the nineteenth-century Quaker attitude toward the attributes of a woman's body. Essentially, the under and outer garments which women wore constricted and concealed the body. In the past few days I have had access to original and reproduction clothing and the curator of Mitchell House modelled them for me. Simply put, the real body disappears into a designed, rigid form.

All this is at odds with my drawings and concept of having the woman revealed beneath rather delicate clothes. I had decided upon the pose I wanted, and I have been modelling the figure nude in a 34-inch maquette prior to clothing it. I normally work that way. I hope to finish the nude before I leave for New York. I have an idea about how I will modify what I had originally intended, and there are a few things at the Metropolitan I need to see to help my thoughts.

—ELLIOT OFFNER, IN A LETTER TO CONVERSE COLLEGE, JULY 29, 2002

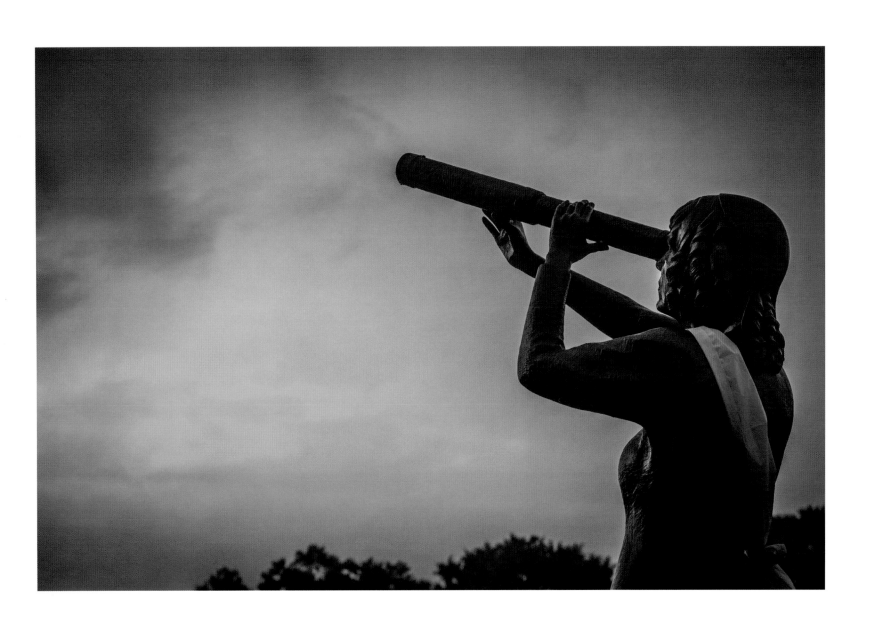

# BILL COBB, CHRIS COX, TIP PITTS & SCOTT PARRIS
## *Floral Clock*
Corner of North Church and West Saint John Streets

*Bill Cobb, chairman and chief executive officer of J M Smith Corporation, is a Spartanburg native, woodworker, and avid amateur musician whose commitment to a vibrant, beautiful downtown is based on "a simple truth: if you want people to come, you have to have a place they want to be." The downtown campus of the J M Smith Corporation, including its arboretum, is one result of that philosophy.*

J M Smith Corporation has had offices in the heart of downtown Spartanburg since 1999. Most people recognize the QS/1 building, but many don't realize that our footprint stretches along West Saint John Street from Church Street to just past the railroad trestle by Daniel Morgan Avenue. We always have been proud of the landscaping and beautification projects we have undertaken on our campus, and in 2011 we came up with a project that would create natural beauty at a major intersection downtown.

Earlier, I had been on a trip to Vienna, Austria, and, walking through a park, came across my first floral clock. It was stunning, and I was awed by it, taking many pictures of this truly unique piece of art. I came back to Spartanburg, mulling over how to bring something like that here. For over a year, a lonely print of one of my photos was attached to the whiteboard in my office. After thinking about it, researching it, and consulting with others, we all realized that if we tilted the clock upwards, it would need a smaller footprint and could fit at the corner of Church and Saint John streets.

We worked with Tip Pitts to design the clock and the plantings, with Scott Parris handling the construction. To the best of my knowledge, there were less than a handful of floral clocks in North America, so finding the clock works was not easy, but we worked with a company in St. Louis that drove the clock works here in a small U-Haul trailer and installed it themselves.

Most major intersections in any town tend to be drab and have a lot of cement. Our clock has become a focal point at a busy crossroads, bringing color, beauty, and function to an otherwise ordinary space. Often, especially in the spring and summer, you can see people taking photos in front of it. People have commented that the clock is something they look for on their daily commute. Others enjoy it as they walk downtown. My hope is that it gives visitors and residents alike an opportunity to enjoy something unique and beautiful in a somewhat unexpected setting.

—BILL COBB

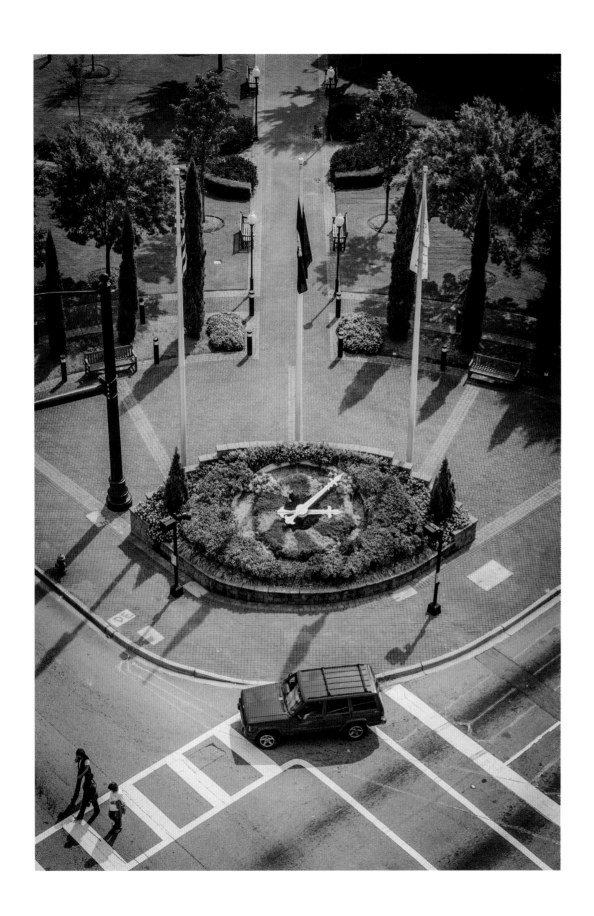

*Michael Baker began working as a sculptor in the 1970s when his initial exposure to the medium in Santa Fe, New Mexico, sparked a creative interest that resulted in the undeniable desire to see where the medium could lead him. A few years later, he began an apprenticeship under well-known Colorado sculptor George Tate. He has exhibited and installed sculptures on the campuses of several North American universities, museums, corporate campuses, designer show homes, private homes, gardens, and recently on the movie set of* Iron Man 3. *He lives in San Jose, Costa Rica.*

# MICHAEL BAKER
## *Solitude*

Hub City Art Park, Corner of West Henry Street and South Daniel Morgan Avenue

*Solitude* was developed to be minimalistic in design and was intended to be an introspective piece with the three square elements representing Mind, Body, and Spirit. I feel the placement in the Art Park is very significant as I believe it not only welcomes visitors, but hopefully gives them a personal reflective moment.

Personally, I feel that public art is an incredible addition to spaces where pieces are installed. A well-chosen piece lends beauty and interest to any location and, depending on the scale and strength of the work chosen, it is within the artist's power to create a landmark while adding cachet to the environment. It also can become the focal point of the space, actually attracting people to it. Because it offers a three-dimensional viewing experience, sculpture adds an element of art and design to the area from every possible angle. Its line and color have the capacity to contribute a transcendent human quality to a natural setting. I feel the most important aspect of sculpture is that it brings aesthetics to the viewer. Comments like, "What is it?", "I like it," and "I don't like it," are good as they start a conversation, which is paramount in an artist's view.

The most memorable response to my work was from a client who stated, "I never thought about placing a sculpture in that space and now I can't imagine it without the sculpture."

—MICHAEL BAKER

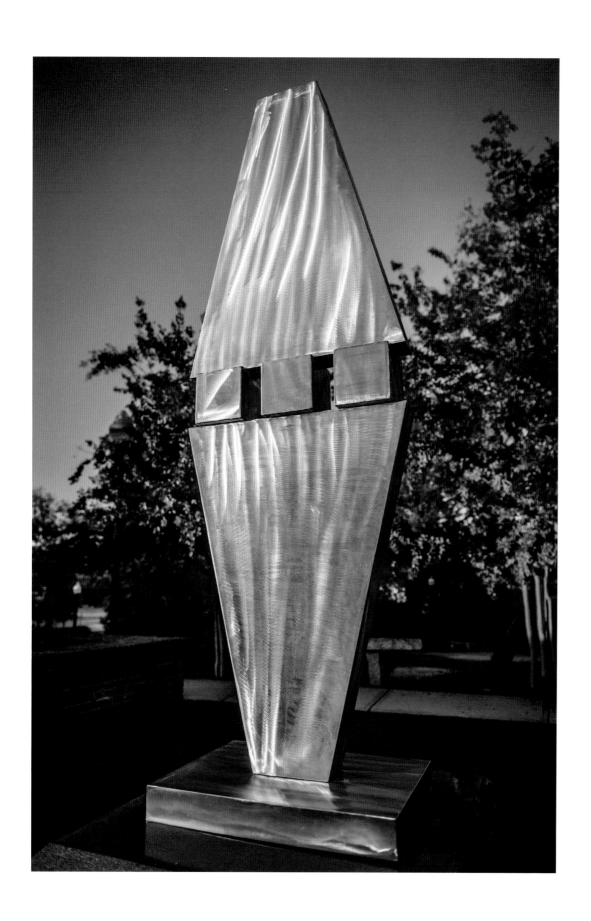

*Mark Byington has been practicing landscape architecture in the Upstate since graduating from the University of Georgia in Athens in 1983. He is director of the Carolinas office of Innocenti & Webel in Landrum and has been the landscape architect for several area projects including Barnet Park, Spartanburg Regional Medical Center's Gibbs Cancer Center Gardens, the Greenville–Spartanburg International Airport Aviation Parkway, the Tryon Fine Arts Center, and RiverPlace fountains and Riverwalk in downtown Greenville.* Transitions *was funded by the Group of 100 in Spartanburg.*

# MARK BYINGTON
## *Transitions*
Corner of Drayton Road and Skylyn Drive

In grade school, I drew and painted quite a bit. I was also intensely interested in nature and natural systems. When thinking about college and potential areas of study, my oldest brother recommended landscape architecture. Being able to combine art and design with the natural world was right up my alley, and I have never forgotten that timely advice.

Since then, site has been a major influencing factor in all my work, especially in this piece in Drayton. In my opinion, the strength of the piece is in its rather simplistic aesthetic composition that reads from various dynamic viewpoints and light conditions as one travels through the intersection over different times of day and night.

Public art imbues a sense of soulful vitality to a community and sets a place apart from the mundane and nondescript. Public art in the landscape is found in many ways, shapes, and forms—both expected and unexpected—in those communities that encourage diversity and creative freedom. Where public art is lacking, a spiritual void exists.

—MARK BYINGTON

# ROSIE SANDIFER
## Nesting
135 North Church Street

*A native of Columbia, South Carolina, Rosie Sandifer was inspired to become a sculptor by wandering Brookgreen Gardens in Pawley's Island as a child. She received her formal training in commercial art at Southwestern State University in Weatherford, Oklahoma, and in art education at Texas Tech University in Lubbock. Trained in portrait and figure painting, she began her career as a portrait artist in the late 1970s and began creating sculpture in the 1980s. Today, Sandifer spends much of her time painting en plein air, enlarging her small sketches into large landscapes, most often depicting American locales. She lives in Santa Fe, New Mexico.*

The two connected bodies are a melded work of art. Conceptually, they are a strong emotional statement. The bond between parent and child may be one of the strongest ones. I passed these two, an older mother with her cherished daughter held close to her heart, on the way to the foundry one day. They agreed to hold the pose for me to draw and photograph them. The title came easily after observing a duck in my yard with her ducklings wobbling along single-file behind her. Soon after this observation, they all left the nest. In my sculpture, the child is still in the nest.

From assembling jigsaw puzzles and drawing in my youth, I have evolved into creating the most artistic sculpture and painting that I can design in my adult life. Building mystery so that the art entices and makes one want to look again is the best that I can do.

One of the most influential people in my career is Electra Waggoner Biggs (1912-2001). I agree when she emphasizes that the only thing remembered about a sculpture is the quality of the work. Biggs created the most noted sculpture at Texas Tech University in Lubbock. *Into the Sunset* is a highly skilled rendition of Will Rogers (1879-1935) on his horse, Soapsuds; another version can be seen at the Will Rogers Memorial Center in Fort Worth, Texas. After completing the statue, she destroyed it to build it again, because it did not suit her. Likewise, Auguste Saint-Gaudens (1848-1907) believed that "a sculptor's work endures so long, that it is next to a crime for him to neglect to do everything that lies in his power to execute a result that will not be a disgrace."

—ROSIE SANDIFER

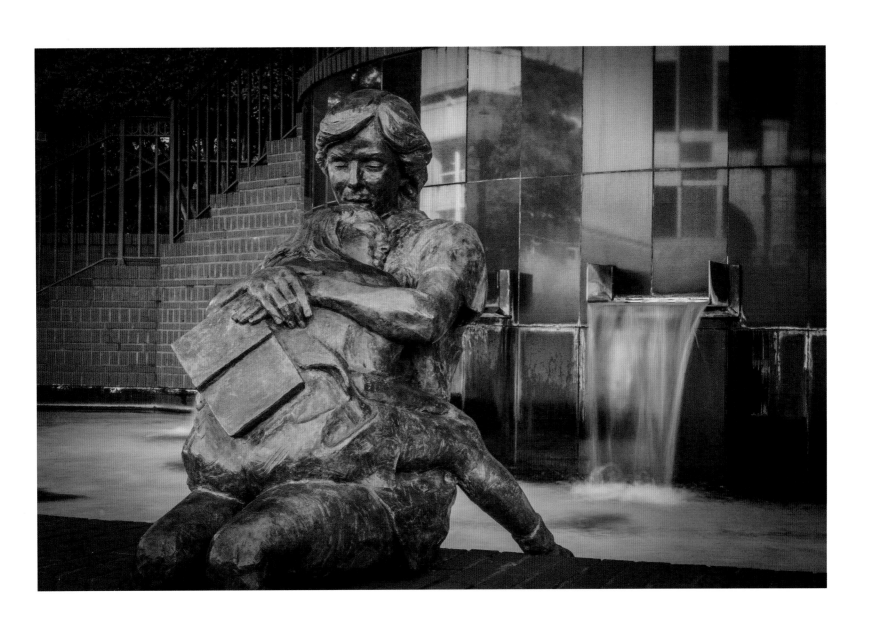

*Mayo Mac Boggs (1942-2014) was born and raised in Ashland, Kentucky. From 1970-2013, he was the professor of sculpture at Converse College. In 2010, he was honored by Converse College, Wofford College, and USC Upstate with a 40-year retrospective exhibition on each of the three campuses, featuring more than 300 pieces of his work. In 2013, he received the Elizabeth O'Neill Verner Governor's Award for the Arts. Boggs is best known for his metal sculptures in steel, stainless steel, and bronze.*

# MAC BOGGS
## *Evolution of Play III*

Chapel Street Park, Asheville Highway

I have been blessed to live the life of an artist and teacher. I have had the freedom to focus on the visual, non-verbal world and the excitement to create my personal interpretation of it. A life of creative thinking is a life of discovery and joy. In addition, I have been fortunate to share my passion for art with my students. The fear of failure has no place in the creative process and interferes with personal growth. I have enjoyed being a participant in my students' growth in self-confidence, in the development of their creativity, and in their experiences as proud contributors to the art world. I teach them to be unafraid, to ignore rejection, to be confident. There are many things one can do to occupy his time while on this earth. I prefer to have non-stop conversations with my soul. My art is my residue.

—MAC BOGGS

Mac often said that making sculpture is like writing poetry. Therefore, pieces of metal of varying sizes and shapes were important to have in his studio, because they were the words from which he chose to make his art. *Evolution of Play III* was site-specific; he wanted the park piece to reflect its location in a formal park in a quiet community at the foot of the mountains. The sculpture includes images of children and a dog which enhance its playful spirit.

—ANSLEY BOGGS, WIFE OF MAC BOGGS

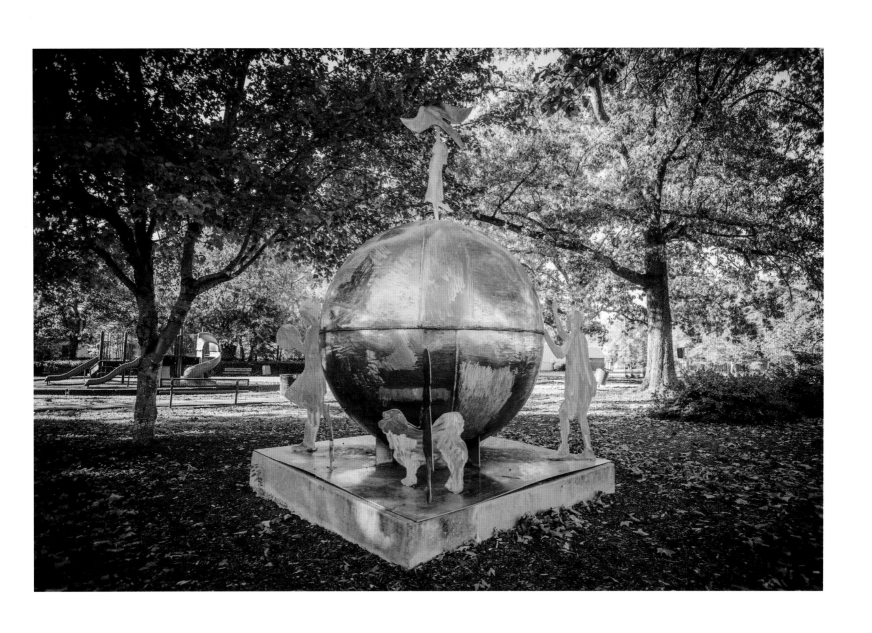

# RICHARD McDERMOTT MILLER
## *Exuberance*
Barnet Park, 248 East Saint John Street

*A former president of the National Sculpture Society and the National Academy of Design, Richard McDermott Miller (1922-2004) lived in New York and was known as the "Figure Sculptor of SoHo." His primary focus was the nude female figure, and upon his death he left his entire collection to Brookgreen Gardens in Pawley's Island, South Carolina. Among the museums that own his works are the Smithsonian Institution's Hirshhorn Museum and Sculpture Garden in Washington, D.C., and the Whitney Museum of American Art in New York.*

Around 1999, members of the Friends of the Arts, a women's organization that promoted the arts in Spartanburg, decided that we would fulfill one final service to the community before disbanding. With our remaining funds, we decided to contribute a sculpture to Barnet Park. One day, while walking through Brookgreen Gardens, some group members came across a magnificent statue of a woman in a striking pose, with wind seemingly rushing through her hair and garments. They immediately knew that the sculptor of this powerful, exuberant piece— Richard Miller—was exactly who should make the sculpture for Spartanburg.

Terry Coleman was the chairman of our committee and pursued the artist relentlessly. He was too expensive for us, but Terry convinced him in her lovely way that he should do this. We flew to his studio in New York City to see the work in progress. To create these spirited sculptures, Miller used female dancers clothed in silk as models for his work. His first draft of *Exuberance* was less modest than the Friends of the Arts preferred, and her placement directly across from the First Baptist Church in Spartanburg led Miller to create a more modestly clothed statue. When she was finally finished, *Exuberance* was carefully shipped from Manhattan to Spartanburg. To complete the work, architect Ron Smith and I traveled to the quarry in Pacolet to choose the stone that would act as a pedestal underneath the sculpture.

Terry would die of cancer at the end of the year. At the unveiling, her husband, Red, drove her to the curb where she could watch from the car. It was very sweet. She mustered all the strength she had left to be there.

—TRACY HANNAH, FORMER PRESIDENT OF THE FRIENDS OF THE ARTS

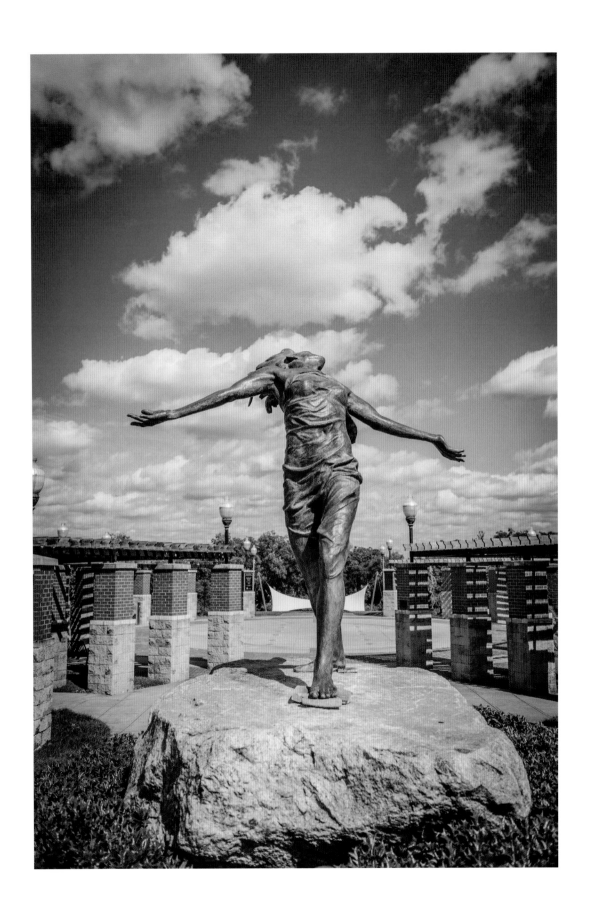

# AIMEE WISE & ABE TITUS
## *Call It*
360 Union Street

*Born and raised in Spartanburg, Aimee Wise graduated from The School of the Art Institute of Chicago in 2008 with a BFA in visual art and is currently employed with the Johnson Collection. She works predominantly in watercolor or acrylic paint, typically with an illustrative or scientific appeal, but she also dabbles in various other creative pastimes. In 2014, she had her first solo exhibition at the Artists' Guild Gallery in Spartanburg titled* Mechanisms of Resilience; *her work also has been featured in Chicago, Illinois; Asheville, North Carolina; Boulder, Colorado; and Los Angeles, California.*

*Abriana Lessington-Titus is a Converse College student studying art therapy. Her work is colorful and highly expressive, often leaning toward abstract realism. Abe seeks not only to evoke emotion through her art, but also to create a sense of whimsical expression that allows viewers to interpret their own creative meaning.*

This mural commemorates the ideals of J. C. Stroble, longtime employee of the Beacon Drive-In and local legend. Stroble, who passed away in 2013, personified strength of character and a humble attitude —ideals that, to me, are worth honoring within our community, if not everywhere. The skate park was right across the street, and there's a lot of seriously good graffiti over there. I can't spray-paint worth a lick, so stylistically I tried to avoid anything that might compete with that aesthetic. My hope was that the finished piece would be bold, bright, and optimistic—and I think it is.

Members of the surrounding neighborhood were so welcoming during the month-long job. The barbers on either side of the building always waved and commented on my progress. One new friend rode up on his bike every day and kept me company for a while. Everyone who traveled past or worked nearby took time to stop and inspect the piece, to offer encouragement, or simply say how excited they were to have this in their neighborhood. I think that public art can be a reflection of how a community feels about itself. That feeling has less to do with the actual art and far more to do with the residents' response to the presence of creativity and how creativity is supported. Public art has to walk a fine line in order to be accessible and appealing to a diverse audience. But I believe that that's what makes it so necessary. When someone has a discussion about public art—as a concept or in connection to a specific piece of art—it doesn't matter whether they love it or hate it. The point is that they're discussing art. And I think that's always a great topic of conversation.

—AIMEE WISE

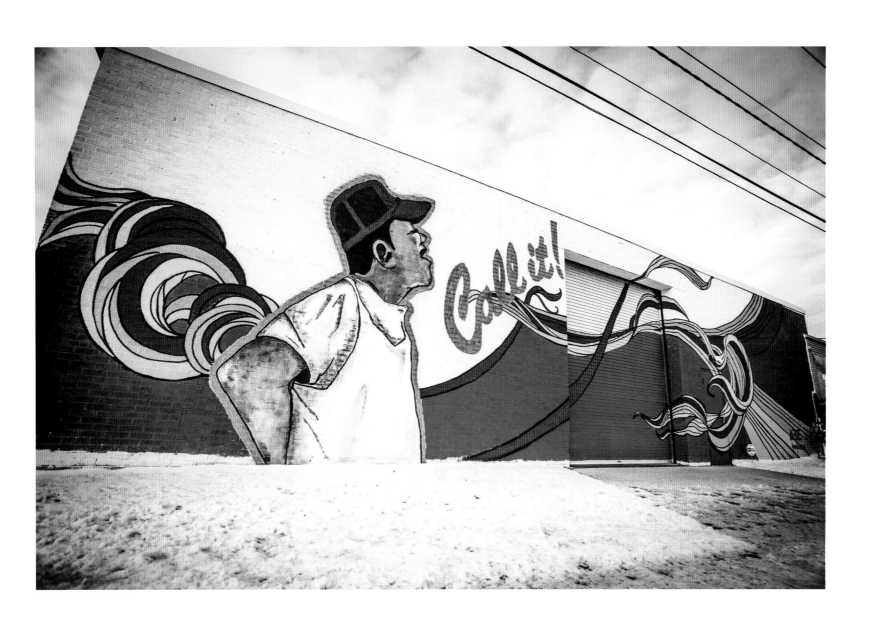

*Abe Duenas is a California native who specializes in creating one-of-a-kind metal artwork. He works from a shop in Gaffney. Nature is often the common theme throughout his work. Abe has been commissioned to create pieces for many parks and celebrities. He is also an award-winning filmmaker, video editor, and photographer. He hopes to pass his knowledge on to his daughter, Sarai, one day.*

# ABE DUENAS
## *Butterfly*

Hatcher Garden and Woodland Preserve, 820 John B. White Sr. Boulevard

Hatcher Garden was improving its front area and wanted to add some sculpture. At the time Stewart Winslow was on Hatcher's board, and we had worked together in the past. He came up with the concept for the big insects. I presented the idea for a ladybug and for the Eastern tiger swallowtail because there are a lot of them around, and you might see them in the garden.

I work in a 30' x 36' shed behind my house where I have a whole blacksmithing operation set up. To make a sculpture like this, you start out with a flat sheet of aluminum to make the exoskeleton. You use a two-foot-round leather bag that is full of sand and start beating out the shape. For the butterfly, there were the eyes, the face, the torso, and the tail. After one pass, the metal hardens so you heat it up again so it softens for you. In the end, you paint the steel with a paint that bonds to the aluminum, and then you airbrush it.

The butterfly is suspended by stainless steel cable in a way that makes you feel that it is flying, poised in mid-air. It moves a little bit in the wind. We wanted it to be a real attention-grabber.

—ABE DUENAS

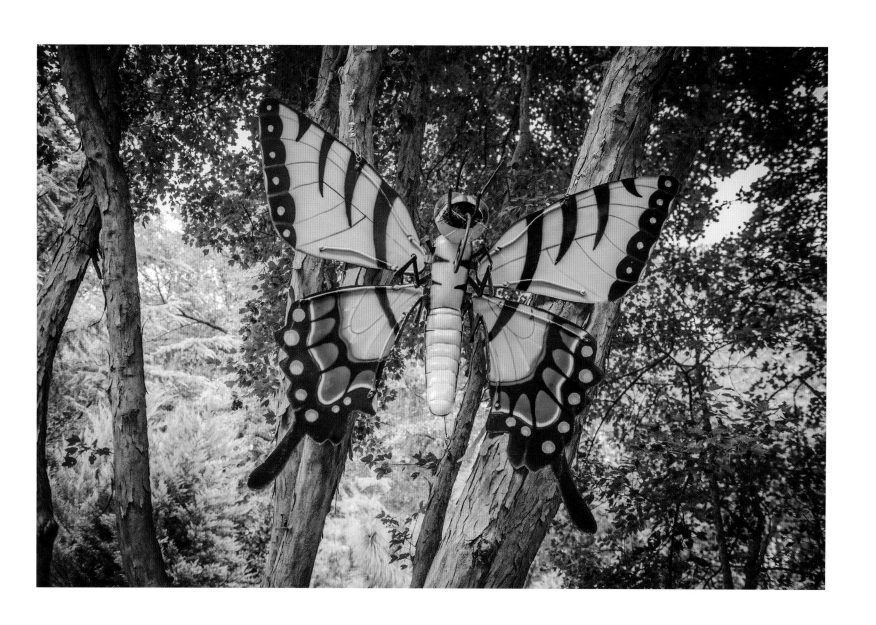

# JEAN ERWIN
## *Menorah*

Temple B'Nai Israel, 146 Heywood Avenue

*Jean Crawford Erwin (1926-2002) was a member of the Spartanburg Artists Guild.* Menorah *is perhaps the largest and best known of her public works; three other examples of her work are held in the permanent collection of the Spartanburg Art Museum. Her sculptures were used as awards for the Civitan Club, the Friends of the Arts, and the Arts Partnership of Greater Spartanburg's David W. Reid Award. As a music lover, she sponsored productions for the Santa Fe (New Mexico) Chamber Orchestra. She also served as set designer for the Charlotte (North Carolina) Opera.*

*Menorah*'s design comprises seven slabs of granite of different proportions to represent each branch of a candelabrum, and it is said to weigh at least seven tons. The branches are delineated by polished and unpolished surfaces that reveal light and shadow. It is positioned to attract sunlight, so that the sun seems to spark and accentuate each candlestick branch. The sculpture was given in honor of Samuel Lyon.

The sculpture was designed and completed in 1992 by Jean Erwin, a Spartanburg artist, who was commissioned by the temple's Grounds Beautification Committee (David and Nancy Lyon, Harry Price, and Junie White) to create a sculpture that would represent the temple and Judaism itself. She considered a version of a shofar, the ram's horn used at prayer services on the High Holy Days, and she also thought of praying hands. From her biblical readings, she envisioned a menorah as a symbol of the Jewish faith. It is the oldest and most authentic of Jewish symbols and is described in the Bible as a ritual object in the tabernacle in the desert and in the holy temples in Jerusalem. Erwin made it impressionistic so that various thoughts might be interpreted by the viewer.

The sculpture's menorah/shofar design motif was later recreated as massive mahogany doors for the Torah ark in the sanctuary. It is also used as the congregation's logo.

—EXCERPTED FROM *PORTRAITS OF A PEOPLE: A HISTORY OF JEWISH LIFE IN A SOUTHERN CITY* BY MARSHA POLIAKOFF

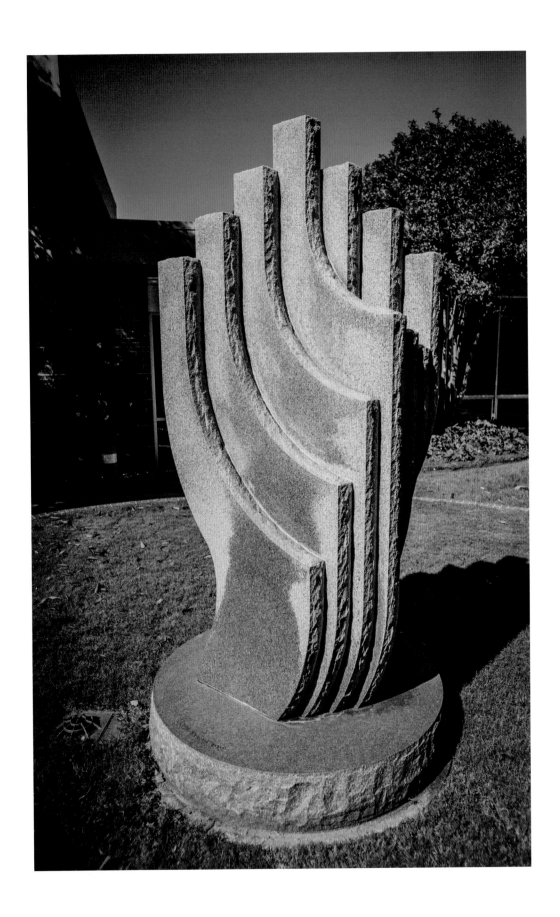

# JIM MORGAN
## *The Peach*

Corner of Asheville Highway and North Cleveland Park Drive

*The late Jim Morgan was the staff artist, editorial cartoonist, and an account executive at the* Spartanburg Herald-Journal *in the 1960s and 1970s. A winner of the 1975 Freedoms Foundation Award, Morgan created a much-loved weekly Sunday comic strip called* The Affluent Society. *Presidents Lyndon Johnson and Richard Nixon, as well as FBI director J. Edgar Hoover, requested original copies of his editorial cartoons.*

Sponsored by the Spartanburg Jaycees, *The Peach* was designed by Jim Morgan of the *Spartanburg Herald-Journal* and crafted by Wood's Monumental Works of Spartanburg. It was envisioned as a memorial to the peach growers who had revolutionized local agriculture and had earned Spartanburg the distinction of producing the greatest quantity of fresh peaches of any county in the United States.

The monument consists of a 15-foot shaft of Georgia marble capped by a two-foot peach with a bronze stem. It was unveiled on August 26, 1947 by Miss South Carolina, Jean Griffin, after a performance by the Spartan Mills band, followed by an address by an official from the Farmers Home Administration, a federal agency responsible for many agricultural loans.

The monument was not universally beloved at the time of its dedication. One letter to the editor critiqued "that monstrous monument" as "one of the most obvious examples of bad taste I've ever heard about" and predicted it would "make Spartanburg a big joke." (One wonders what they would have thought of the Gaffney "Peachoid" along Interstate 85.) At any rate, the monument did not last long in its first location on the upper end of Morgan Square. A newly implemented traffic design just a year or so later resulted in its removal from Morgan Square entirely. It was eventually relocated to Asheville Highway, on the outskirts of Cleveland Park.

—BRAD STEINECKE, ARCHIVIST AT THE SPARTANBURG COUNTY PUBLIC LIBRARIES

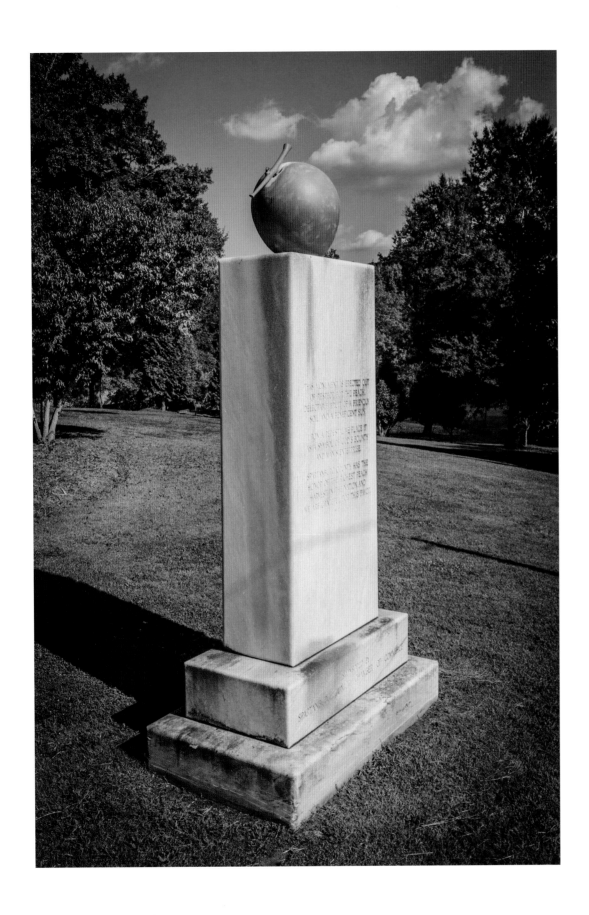

*A native of California now living in Belgrade, Montana, Jim Dolan is known for his Western wildlife in bronze, copper, and steel, ranging from tabletop size to a golden eagle with 36-foot wingspan installed in Osaka, Japan. He has created more than 170 large-scale public pieces worldwide, as well as scores of private works. He also created six-foot-tall blue heron sculptures for the Gibbs Cancer Center at Spartanburg Medical Center.*

# JIM DOLAN
## *Wild Buck*
Dunbar & Zimmerli Outfitters, 509 Union Street

I studied agriculture, not art, and I knew animal anatomy very well when I began sculpting. I didn't know then that you could make a living at it, but now I've been a sculptor for 44 years. I do a lot of animals and people, and I do a lot of work with Indian reservations where I have sculpted teepees. I was contacted by Kurt Zimmerli of Spartanburg to produce this piece for his son's hunting store. What a great guy Kurt is—such a Southern gentleman, who just happens to be from Switzerland. He and his wife, Nelly, really love the Spartanburg community, and they are super people.

Last year, I did four big elk that went to a business in Japan. And then I did 39 blue horses up on a hillside in Three Forks, Montana. They were my gift to Montana for supporting me in all my years of sculpting.

Most of my work is total fun. I usually start at six in the morning. My studio is at my house, and I usually just dance across the floor going to work.

—JIM DOLAN

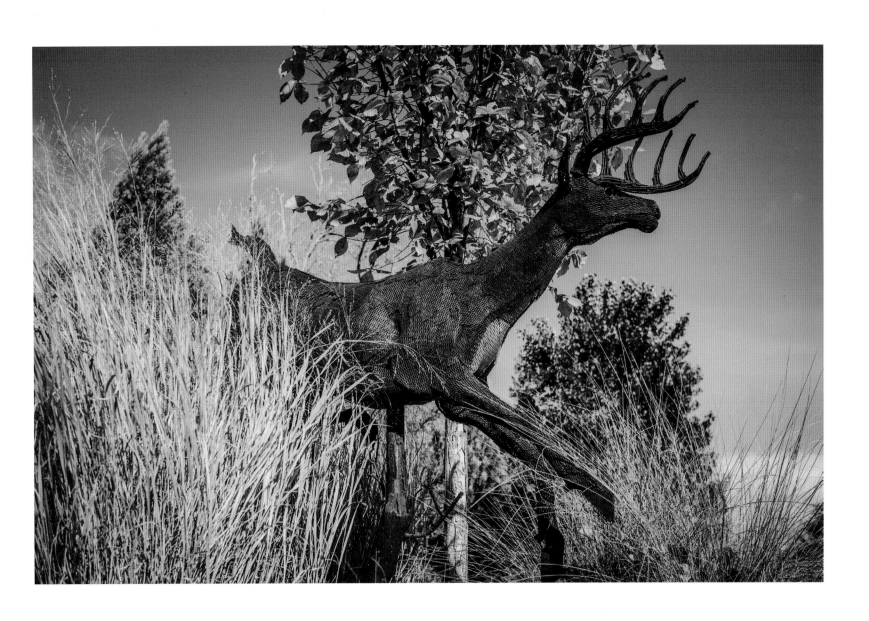

## PETER WOYTUK
## *2 Ravens 10 Apples*
Converse Plaza, 1200 East Main Street

*Peter Joseph Woytuk was born in 1958 in St. Paul, Minnesota. He was raised in Massachusetts and graduated from Kenyon College in Gambier, Ohio, in 1980 with a degree in art. After college, he had an old-school style apprenticeship with sculptor Philip Grausman in Connecticut, where he learned the techniques of modeling clay, mold making, and bronze casting. This training provided him with the skills needed to transform his artistic visions into sculptural form. His animal sculptures have been exhibited throughout the United States and Asia, and are represented in prestigious private and institutional collections, including the Huntington Botanical Gardens in San Marino, California, the Weisman Art Museum in Minneapolis, Minnesota, and the North Carolina Zoological Park in Asheboro, among others.*

Though his college art education focused on photography, Peter Woytuk pursued advanced training in sculpture. Over the course of a four-year apprenticeship, he found himself fascinated with various forms of animals—and birds in particular—resulting in an original series that explores a unique sense of volume and suspended motion. His impressionistic ravens demonstrate a remarkable liveliness that highlights the birds' inquisitive, mischievous nature. Woytuk's research on ravens revealed that the adult birds "spend a good 90 percent of their lives playing because they're so adept at survival."

Woytuk also enjoys altering the scale of everyday objects such as tools or fruit, which in his hands are transformed into animated participants in a composition. More recently, he has produced life-size and monumental sculpture, including his 2011 installation of 18 whimsical sculptures—including bulls, ears, elephants, and sheep—along Broadway Malls, a New York City greenspace stretching from the Upper West Side through Harlem and Washington Heights.

—COURTESY OF ANNE REED GALLERY, KETCHUM, IDAHO

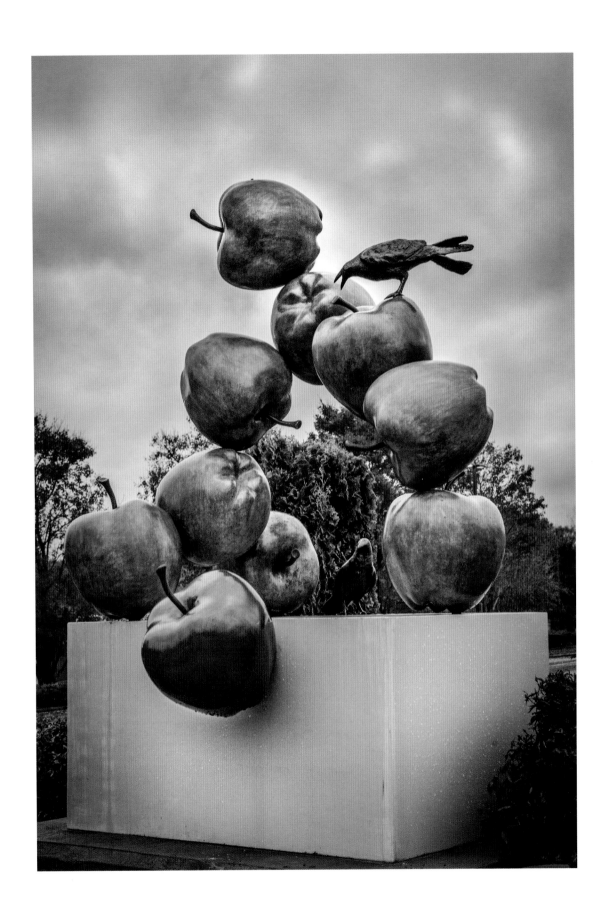

# BARBARA BORDOGNA
## *Welcome to Pacolet*
180 Montgomery Street, Pacolet

*Barbara Taylor Bordogna is a Smithfield, North Carolina, native with a degree in painting from William & Mary and an MA from the University of North Carolina-Chapel Hill. A retired educator, she spent 34 years teaching in the public schools of North and South Carolina, the last 24 in Pacolet. She has painted murals in Pacolet and Spartanburg, including an interpretation of the Pacolet Town Covenant on the T. W. Edwards Recreation Center in Pacolet. She continues to make art every day in her studio in Converse Heights in Spartanburg.*

*An active community volunteer and public servant, Elaine Harris (1946–2015) served as mayor of Pacolet from 2001 until her death.*

Pacolet Mayor Elaine Harris had a framed map of the model mill village that was drawn when the village was in the planning stages. Pacolet's mill village was a planned community that visitors from the North were shown as an example of the progressive South. I enlarged the ink drawing and painted it in a sepia tone that matched the original. The town rented a scissor-lift to take me up and down at the push of a button.

People would drive up while I was at work and watch me painting. After a while they would step out of their cars, walk over to the wall, and point to a house on the map. Many would say, "That's where I grew up ... I remember." Then would come a story that brought my image to life. The stories they told me revealed a vibrant community structure of hard work, baseball teams, interesting personalities, gossip, and intrigue. The mural took about three months to complete during a hot summer. I got really good at painting shadows on the sides of frame buildings and came to appreciate the thought that went into the village: trees in every yard, porches, room for big families and couples, streets for each level of the mill hierarchy.

—BARBARA BORDOGNA

In 2004, we had a master plan done through a charrette process funded by the state Commerce Department and the Urban Forestry Commission. They suggested that since Pacolet had gateway signs on US Route 176 that we needed a gateway from the Cherokee County side. Several years earlier, we had come upon this artist's rendering of the plan to rebuild the village of Pacolet after the flood of 1903, and we decided to make this image our gateway. What we have is not only a really nice welcome, but a piece of history. We find people will come back to Pacolet and take their picture in front of the mural, pointing out where they once lived. I never realized how much value one mural could have to our local residents and to visitors.

—ELAINE HARRIS

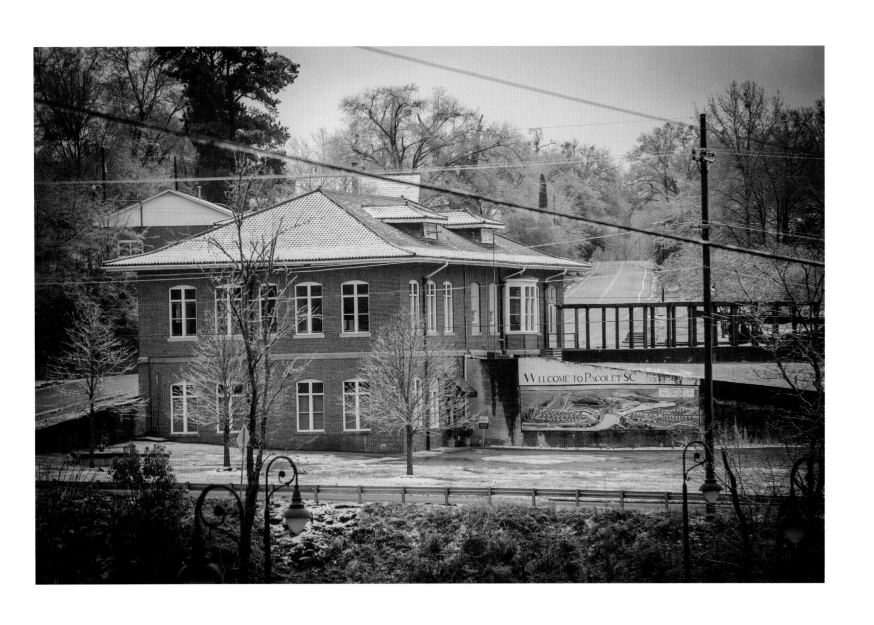

## BETSY SCOTT & CARL McCLESKEY
## *Wofford Terrier*
Wofford College, Campus Life Building

*Carl McCleskey and Betsy Scott, a husband-wife team, are among the nation's most respected wildlife sculptors, and their studio, Wildlife Bronze, is in Cloudland, Georgia. Their wildlife sculptures have been displayed at the Audubon Zoo in New Orleans, Louisiana; Cypress Gardens in Winter Haven, Florida; and the Toledo (Ohio) Zoo, among other places. As children, they had an immense appreciation for nature and animals. McCleskey grew up exploring creek banks and swamps, and scouring freshly-plowed fields for Indian artifacts in rural Georgia. Scott is a former Spartanburg resident and a graduate of Emory University in Atlanta, Georgia.*

The challenge we faced in sculpting Wofford's mascot, a Boston terrier, was to convey the tremendous spirit of that small dog. We chose a stance that we hoped would reflect the proud nature and indomitable character that he embodies as Wofford's mascot. The use of a rising diagonal base creates an underlying dynamic sense of power and movement, but he's a sweet dog, nonetheless. We sculpted *Wofford Terrier* larger than life-sized in an effort to capture and convey the size of the Terrier's spirit, rather than the physical scale of the dog.

Commissioned by Wofford's Class of 1956, the Terrier has elicited a variety of responses around campus. Stories abound about the care students have lavished on their mascot. One young lady actually knit a scarf for him to get him through a stretch of cold weather, and bowls of food appear at his feet every so often. He also turns out wearing appropriate garb when the occasion demands, even sporting a wreath around his neck at Christmastime. He's a dapper little fellow, after all.

He graciously posed for *Forbes* magazine in an article about Wofford, generating some suspicion that he just might have become a secret financial adviser to Warren Buffet and Steve Forbes. He's become part of the graduation ceremony and has been included in countless graduation photos. All in all, he's found acceptance and affection as part of the Wofford community.

—BETSY SCOTT AND CARL McCLESKEY

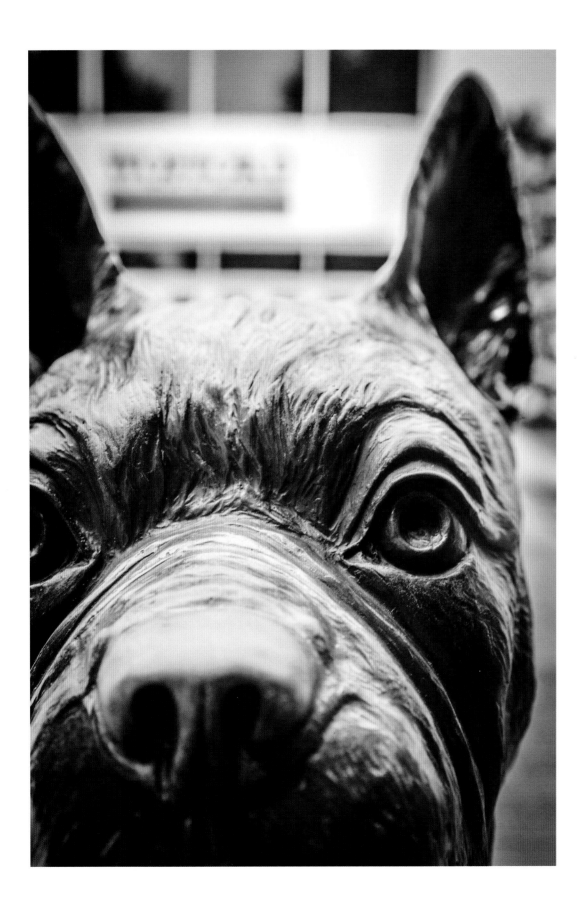

*Thousands of Gary Price sculptures are in public and private collections around the world—in homes, galleries, museums, cities, universities, and corporations. A member of the National Sculpture Society, he was commissioned to design the 300-foot Statue of Responsibility on the West Coast, which will be a companion to the Statue of Liberty. He lives in Mapleton, Utah, and he and his wife, Leesa, have nine children.*

# GARY LEE PRICE
## *Circle of Peace*
Barnet Park, 248 East St. John Street

I watched a television interview with a former white supremacist. At age eighteen, he was imprisoned because of his violent acts. The interview became very interesting to me as he recounted his reformation while in prison. He told how, prior to his sentence, he vehemently avoided people of other races. Simply, they were to be hated, they were to be abhorred, and they were to be despised. For a time, he was in solitary confinement. Overnight, he was placed in an environment where interaction with men of many colors and from many cultures was a welcome experience. Relationships developed. Biases subsided. Upon release from prison, he found himself free from the prejudices and bondage that previously had tied his hands and soul. Today, he takes a radical stand against such actions, like those found in his own sordid past, by speaking out in public forums. He exposes the thought process and violence of hate groups. He coaches a multi-cultural youth hockey team.

This story fascinates me. The prejudice could only occur when there was no interaction. When the associations were built, the barriers were destroyed. Friendships occurred. This idea is what *Circle of Peace* represents—portraying children from all walks of life playing with and enjoying each other. The circle that the children form represents the continuum of humanity. The clasped hands represent interaction and cooperation, together with compassion and respect. Respect for each other's uniqueness bridges the gap between any difference.

I created a space in the circle, and it is fascinating to watch children interact with the piece. Quickly, they notice the gap and instantly clasp the two outstretched hands and complete the circle. Each and every person is a vital element in this wonderful circle of life.

—GARY LEE PRICE

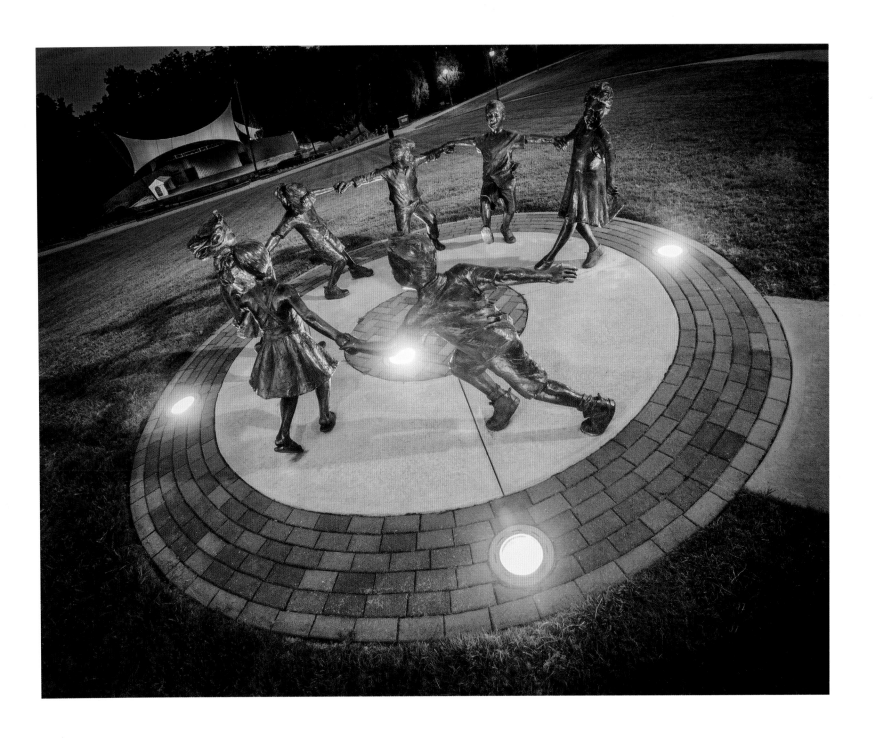

## ROGER MILLIKEN
# *The Red Spout*

Milliken & Company Customer Center, 920 Milliken Road

*Roger Milliken (1915-2010) led Spartanburg's Milliken & Company as president, chief executive, and chairman for 63 years and is considered the greatest innovator in the history of the United States textile industry. Milliken also was the long-time leader of the Greenville-Spartanburg Airport Commission. Over the years, he commissioned numerous fountains and sculptures at the airport and for his corporate grounds, and also influenced others in the Spartanburg community to invest in public sculptures.*

*Richard C. Webel is the president of Pacolet Milliken Enterprises, Inc. He is the former managing partner of Innocenti & Webel, one of the nation's oldest landscape architecture and land management firms.*

*The Red Spout*, as it has become affectionately known, was built when Roger Milliken added the Customer Center to the Milliken Research Campus in the late 1980s. About that same time, Milliken was building a carpet tile plant in Yonezawa, Japan. While we were in Japan, he and I saw a red gazebo that livened up what would have been a very boring landscape. He developed a fixation about this—he really wanted something red at the Customer Center.

So we sat down and began looking at lots of architecture books and discovered the work of Luis Ramiro Barrigán (1902-1988), a Mexican architect who had won the Pritzker Architecture Prize, the highest honor in that profession. He had these terrific orange and pastel water sculptures. Mr. Milliken crossed what he saw in Japan with the work of Luis Barrigán. So in the end, I was the finder and he was the creator. Mr. Milliken went to Buddy Harmon, the company's chief engineer, and said, "Here's the picture. Can you make it?" The first version wasn't shiny enough. The red glaze you see on it now is actually automotive paint.

The goal of sculpture is to be timeless and evocative—a form that makes people think and ask questions. *The Red Spout* achieved its goal, thanks to Roger Milliken's insatiable curiosity and love of design.

—RICHARD C. WEBEL

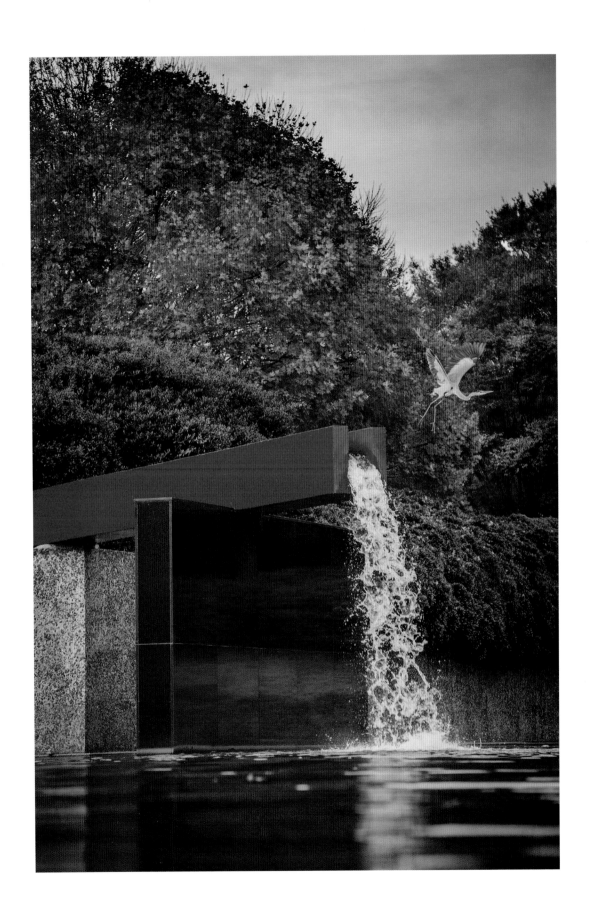

# RUSSELL BLACKWELL
## *Hardwood Trees*
306 Gossett Road

*Russell Blackwell, a self-taught artist, was born in 1954 in an old farmhouse near Chesnee and graduated from Gaffney High School. His father was a blacksmith and a welder. He began as a welder for a local cotton mill; then construction jobs took him all over the world. Since opening Colonial Gallery in 2000, he has created work including a life-sized King Nebuchadnezzar with a falcon landing on his arm, a Roman centurion, and a large wind vane outside his shop. His work was featured in the opera* Troiades *at Converse College in 2015.*

The only thing I ever wanted to do was to be a creator. I was living out west and I spent a lot of time in my life daydreaming about creating works of art. Not just for an afternoon, or even a day, but for days on end. Even for weeks at a time, I would construct things in my mind. I started to plot my life. I would go back to South Carolina and buy some land. I would build a welding shop. I would learn how to build sculptures out of steel. I would listen to no one who told me I could not do it (and believe me, they were too numerous to count). I would put my creations in a room for five years—my five-year plan. I would only bring in enough work to pay my bills. I would not advertise or ask for work. I would put every day, seven days a week, 12 hours a day, into my sculptures for five years. And I must say, it was an agonizing five years, which became eight years. Many a day, I said I could not go on, but I would not stop.

I built these trees when I was contracted by Spartanburg Regional Medical Center to make some 19-foot-tall trees as decorations for a big dinner gathering at the Spartanburg Memorial Auditorium. I also made three large chandeliers to look like limbs. I thought the hospital was going to sell the trees, but they ended up coming back to my property on Gossett Road. I took the eight half-trees and made them four full trees—37 feet tall—and took the chandeliers and made bonnets of limbs on top. It took me about a year to put together. I had a crane come over, and I built an apparatus on my trailer to haul them to the front. I bolted them down and turned on the lights. Everybody certainly notices them.

—RUSSELL BLACKWELL

*Jim Gallucci works full-time designing and fabricating sculpture in his studio in Greensboro, North Carolina, assisted by a staff of six. Most of the works are commissions for public, corporate, and residential spaces around the country. He designed the 52-foot-long gate for First Horizon Park, the Greensboro, North Carolina, minor league baseball stadium; the 62-foot-long* Whisper Gates *for Marbles Kids Museum in Raleigh, North Carolina; and the* Veterans' Memorial Archways *in Rockville, Maryland. He has an MFA in sculpture from Syracuse University in Syracuse, New York.*

# JIM GALLUCCI
## *Gothic Gate*
University of South Carolina Upstate, Performing Arts Center

In 1996, 60 to 70 sculptors gathered at USC Upstate for a tri-state conference. Each artisan was asked to bring a piece to display. At the show, *Gothic Gate* was purchased and donated to the college by a family who wanted to honor a daughter who had died in a car crash. This sculpture has different parts that are assembled into a gateway. For this family, the arch and the opening gate represented the passage of their daughter, and so the sculpture took on a deeper meaning. We find this happens with our art fairly often. Art for me has always been rather mystical. Several times, it has saved my life.

I started doing gates back when I proposed one for Bayonne, New Jersey. The city wanted to honor the survivors of the Holocaust, and I was going to include cast hands of some of the witnesses. My idea came in second place, so it did not get fabricated, but after that I started making immigrant gates. My father and grandfather emigrated from Italy.

Gates have a universal meaning and purpose. They have been found throughout the history of Western civilization not only as utilitarian architectural elements, but also as symbols in art and literature. This symbolism arises from the paradox that the gate inherently possesses. A gate may be opened or closed; it can be a way of passage or obstruction, a means of confinement or release. I use the format of gates and doors in my sculpture in order to give the public access to my art. This interaction is an entry for the public to embrace art.

—JIM GALLUCCI

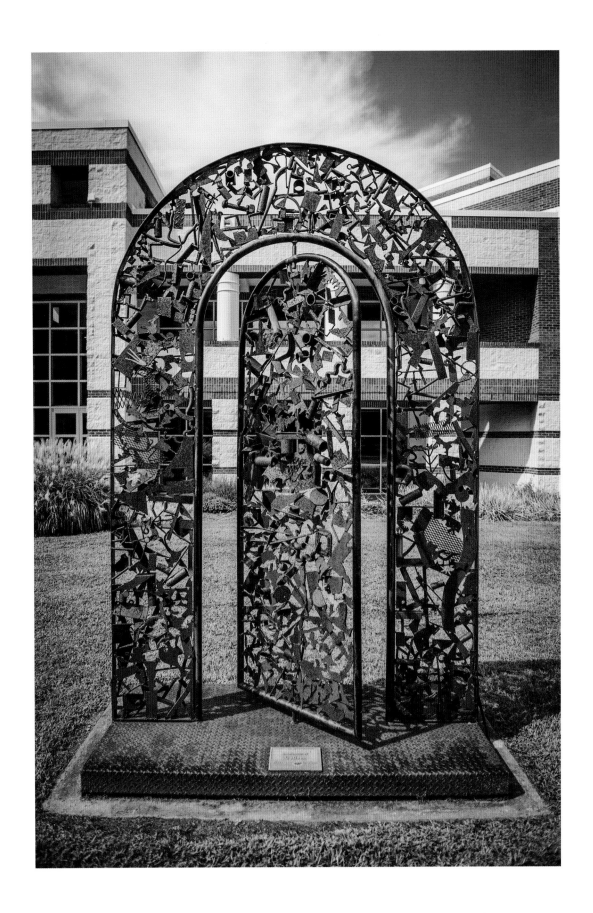

# JIMMY O'NEAL
## *Seven Waters*
TD Bank, 340 East Main Street

*Born in Atlanta in 1967, Jimmy O'Neal lives and works in the mountains of Asheville, North Carolina. He is a classically trained painter with an interest in physics and biology. His work has been shown in and collected by various museums, including the Museum of Contemporary Art in Jacksonville, Florida, the Santa Fe (New Mexico) Art Institute, Moot Gallery in Hong Kong, and the North Carolina Museum of Art in Raleigh. He also has been commissioned to create works for the Philadelphia (Pennsylvania) International Airport, the Milton Rhodes Center for the Arts in Winston–Salem, North Carolina, and Black Mountain College Museum in Asheville, North Carolina, among many other institutions.*

This resin installation commissioned by Johnson Development Associates centered on creating a collection of sculptures in honor of the surrounding shoal locations in Spartanburg County, using aerial photos and topographic maps. I see strength in the conceptual scale shift from the micro of a water-worn piece of green bottle glass found in a waterway to the macro-perspective of each of the seven locations being represented in topographical form with accurately worn shoals from the various area locations within the piece. From left to right, they are Anderson Mills Shoals, Ghost Valley Shoals, Musgrove Mill Shoals, Mountain Shoals, Glendale Shoals, Nesbitt Shoals, and Hurricane Shoals.

The most memorable response to this piece was from a local artist named Slobot, who within weeks of the piece being installed, created a webpage thanking me for creating it. Slobot is an anonymous artist who wears a box over his head with eyes drawn on.

When public art works, I feel it gives the public an opportunity to engage with a new poetic perspective on their surroundings.

—JIMMY O'NEAL

# PETER FERRARI
## *Offering*
Hall Street Parking Deck, corner of East Main and Hall Streets

*Peter Ferrari was the winning candidate in the Concrete Canvas Mural Competition, a 2014 competition launched by the Johnson Collection to contribute to Spartanburg's vibrant public art environment. A visual artist living in Atlanta, Georgia, Ferrari produces work that ranges from large-scale murals to small-scale ink drawings and tattoo design. He describes his work as highly graphic, with strong hard lines and shapes. A former educator, Ferrari also is involved in an innovative Atlanta arts cooperative known as Forward Warrior that collaborates to create public art events that engage the public.*

The style I used for this site is very malleable. It can fit nicely into any space. I wanted to have the raw concrete exposed at the top and then a very dense mass on the other side. I think it worked very nicely, given the slant of the hill and the wall. The strength of this piece is how well the colors work together. I especially like their tone against the grey, unpainted concrete.

This piece depicts an altruistic gesture or presentation from an unknown source. The hand comes from an abstract, layered form, which seems to be the source of this presentation, from which the flowers are raised by an unseen person, to be observed or otherwise enjoyed by the viewer.

I believe public art in general beautifies our surroundings. It uplifts the spirits of those who pass by and inspires new creativity. It creates a point of pride in a community and encourages others to do good as well. Best of all, once a piece of public art is up, it is free for all to see.

—PETER FERRARI

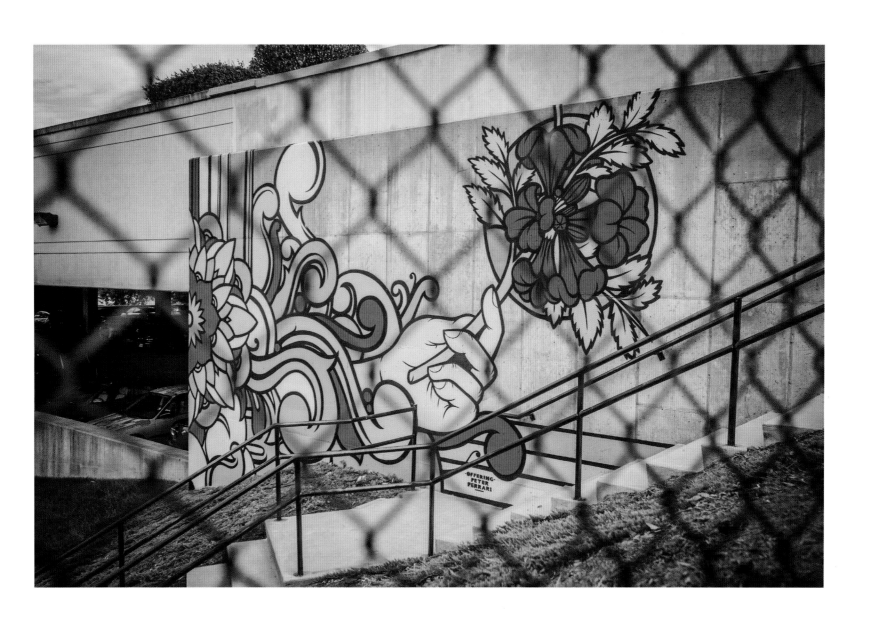

# MEREDITH BERGMANN
## *Marian Anderson*
Converse College, Twichell Auditorium

*With more than 30 years of experience, Meredith Gang Bergmann is a sculptor who enjoys working with complex themes in an accessible, beautiful, and stimulating way. Her motto for her work is "to move, to teach, and to delight." She works within the tradition of narrative sculpture and draws on her love of art history, literature, and mythology to make the past speak to the present. Meredith lives in New York City with her husband, a writer and director, and their son.*

Marian Anderson (1897-1993) was an African-American contralto and one of the most celebrated singers of the twentieth century. For me, she represents foremost one essential liberty: the freedom we all deserve to claim any of the riches of human culture for our own, to study anything that we feel drawn to, to participate in any art form, to develop whatever artistic gift we have, no matter where we come from. Anderson mastered and enriched the classical tradition with her astonishing and unmistakable voice, as well as brought to it the music created by her enslaved ancestors, music that kept their spirits alive in spite of great suffering.

She represents an attitude towards evil that I admire deeply. She would not succumb to it or retreat from it. She would not be denied the audience she deserved even if she had to cross the ocean to find it. When she returned to us—a star—her defiance of stereotypes was so gracious and so focused on the undeniable rightness of her beautiful singing that she changed this country forever. She moved us to recognize the evil and injustice we allowed ourselves to live with, and we changed our lives and our country to correct it.

I believe people make my work their own. They find meaning in it, love it, and protect it.

—MEREDITH BERGMANN

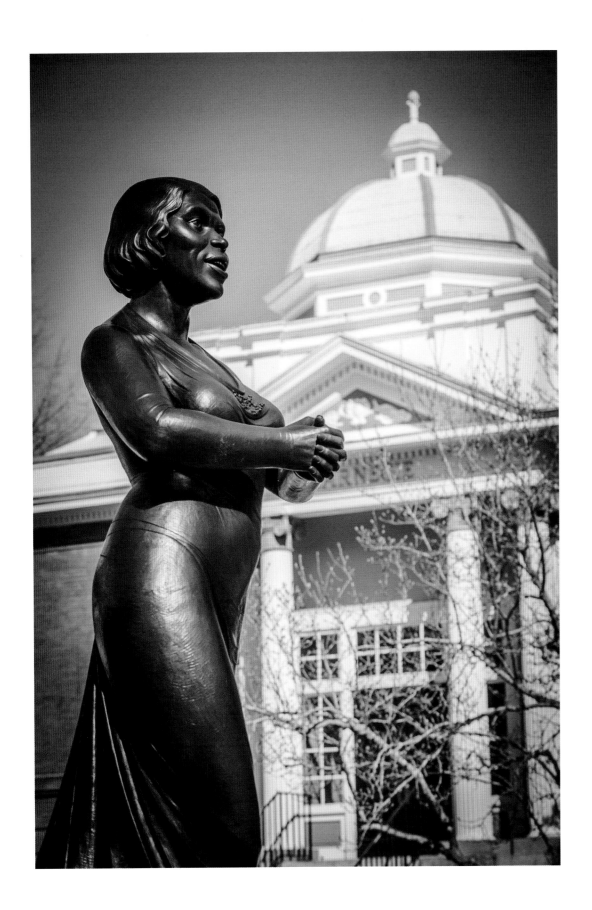

*Kathy Zimmerli Wofford is the director of the COLORS Program, an art studio for inner-city youth founded in 1993 at the Spartanburg Art Museum. Kathy serves as a volunteer for several charitable organizations. When she is not creating, she enjoys spending time with her family and her new puppy.*

# KATHY WOFFORD
## *Palmetto Trio*

Converse College, corner of North Pine Street and Drayton Avenue

*Palmetto Trio* was created as part of a special class at Converse College that Professor Mac Boggs taught in cooperation with professors from Wofford College. This class explored the fusion of kinetic sculpture and physics. Professor Boggs also enlisted the expertise and equipment of local metal fabricators who helped us with designs and fabrication using the CAD system.

The inspiration for my piece came from the surroundings in nature that I was exposed to as a child and a young adult. I wanted to create something that related back to South Carolina. The shape of the orange piece represents the foothills, while the color signifes the red clay of South Carolina. The shape and color of the green piece represents the forests and diverse flora in our state. The blue piece naturally represents the rivers, lakes, and coastline for which South Carolina is quite famous. It was originally installed in the courtyard in front of the Phifer Science Hall, but was moved to its current location on the hillside facing Pine Street when the

new senior housing was built. It is on permanent loan to the college.

Growing up, I always enjoyed arts and crafts as a hobby, but my first career was as a chef. I lived away from Spartanburg for a few years and returned when I married. My father, Kurt Zimmerli, had been involved with Converse College for many years. He gave me a tour of the art department and I agreed to take one class. I enjoyed it so much I stayed six years, getting my undergraduate degree in studio art and my master's in art education.

The first thing people say when they see this sculpture is, "It moves!" and it does. The wind gently pushes the pieces so they twist and actually interact with each other. People say it looks different every time they see it. Just like a landscape or a favorite place from our youth, things change but also retain a familiarity.

—KATHY WOFFORD

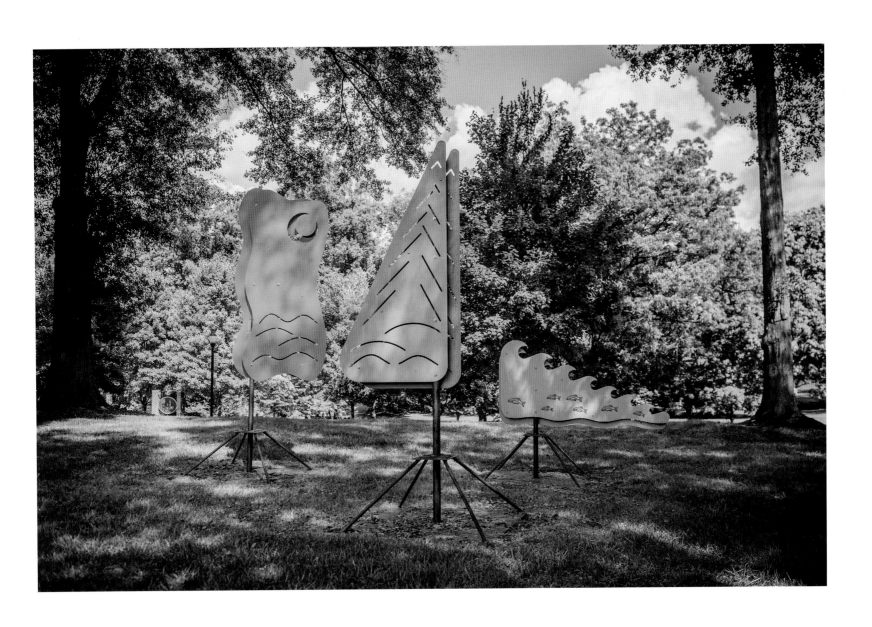

## GARY LEE PRICE
### *Journeys of the Imagination*
Spartanburg Downtown Memorial Airport, 500 Ammons Road

*Thousands of Gary Price sculptures are in public and private collections around the world—in homes, galleries, museums, cities, universities, and corporations. A member of the National Sculpture Society, he was commissioned to design the 300-foot Statue of Responsibility on the West Coast, which will be a companion to the Statue of Liberty. He lives in Mapleton, Utah, and he and his wife, Leesa, have nine children.*

Of all the sculptures that I have created over the years, this series is one of my favorites—and one that was very therapeutic for me. Each piece represents the freedom and the joy for life that so many of us lose sight of in our busy and responsible lives. The mail-order glider, paper airplanes, and pogo sticks become symbols of our dreams and aspirations.

I also wanted to say something about childhood and our fascination with flight. To me, flight represents freedom and rising above our problems and gaining that all-so-important perspective on life. I feel like I have to take a couple of flights a year just to get off of the earth and regain some of that vision.

—GARY LEE PRICE

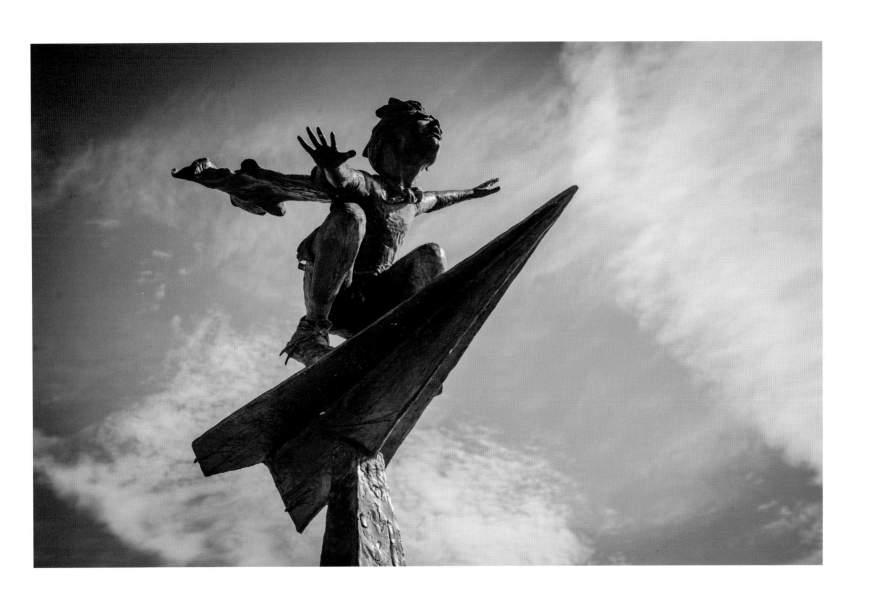

# BOBBIE CARLYLE
## *Self Made Man*
Magnolia Street, near the corner of Dunbar Street

*Bobbie Carlyle works in bronze and stone, creating compelling sculptures that deal with the complexity of emotion, human struggles, and triumphs of life. Her pieces range from dynamic and historic figures to Western sculptures, wildlife, and liturgical pieces. She takes her influence from Rodin, Michelangelo, and Daniel Chester French. Her works, including reliefs, fountains, and monuments, are displayed internationally in public and private collections. She lives and works in Loveland, Colorado.*

My style in sculpting is classical. This sculpture has a timeless feeling to it in style and also in its meaning. The meaning is a truth that all human beings must take accountability for where they are in life, for how their own decisions brought them to that point in life, and for where they go in the future.

A divorce was a life-altering experience for me. Having to confront myself and redirect my life challenged me immensely. From all this, I found a greater strength and commitment to make my life count, for myself and for others. In doing so, I found a number of people who had just such an epiphany and related to the sculptures that I created. It has been humbling to talk with others who have gone through great hardships and have recognized themselves in *Self Made Man*. The scratches and gouges in the sculpture are made with intent, as this is also what happens in life. But there also are areas of refinement, which only comes after much labor and focus.

—BOBBIE CARLYLE

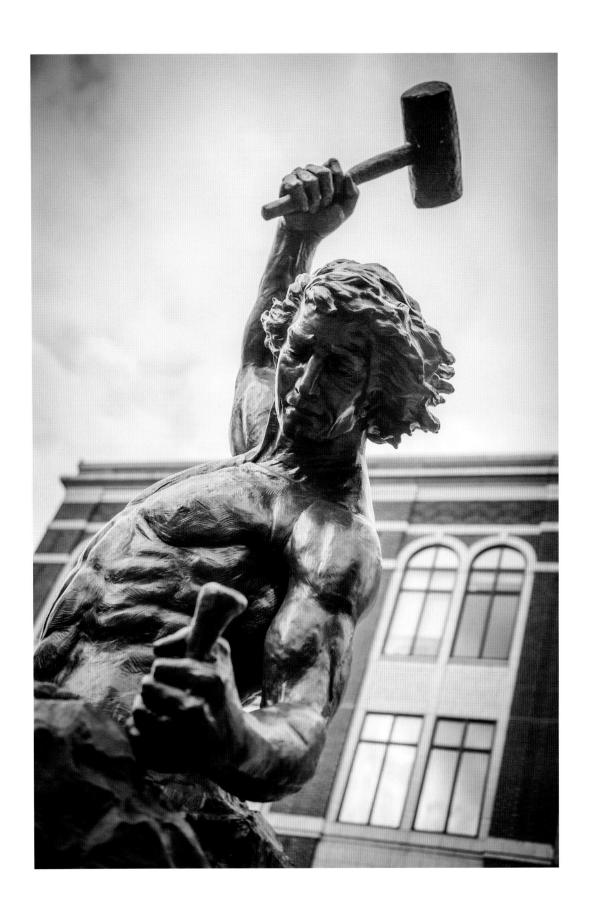

# VIVIANNE CAREY
## *Monarch Caterpillar*
Hatcher Garden and Woodland Preserve, 820 John B. White Sr. Boulevard

*Vivianne Lee Carey was born in Millville, New Jersey, in 1959 and lives in Spartanburg. She is a sculptor who works primarily in metal and glass. Her work is featured on the Cottonwood Trail, at Hatcher Garden, at Happy Hollow Park, and in private collections. Carey has exhibited her work at the Chapman Cultural Center, Converse College, Winthrop University, and other regional venues. In 1981 she received her BFA from Converse College and is pursuing an MFA at Winthrop University in Rock Hill. She is an adjunct art professor at Converse and was an art teacher at St. Paul the Apostle Catholic School for eight years.*

This sculpture was a commission in 2008 from the Fannie Louise Holcombe Garden Club and my friend Joyce Richardson, who has encouraged me for years. The enormous monarch caterpillar straddles a split-rail fence at the edge of Hatcher Garden's beautiful butterfly garden. I love creating organic-based art.

There was a lot of trial and error in creating this sculpture. The challenge was to make a four-foot cylinder with an 18-inch circumference light enough to balance on a small section of split-rail fencing. His armature consists of antennae that go all the way through, heating ducts, chicken wire, bits and pieces of steel, and a lot of Bondo to hold it together. The heavily textured black and gold outer surface of the caterpillar is a mosaic made from broken plates, coffee mugs, and stained glass.

Everything for me is an experiment. I enjoy using materials that are new to me—that's what makes it fun. At the same time that I was commissioned to create the caterpillar, I had been making giant fleas and bedbugs, so the new critter challenge was pretty cool.

The children who come to Hatcher Garden really like this sculpture. They climb on it, which they are not supposed to do. Many Hatcher Garden visitors also like to have their photographs made in front of him.

—VIVIANNE CAREY

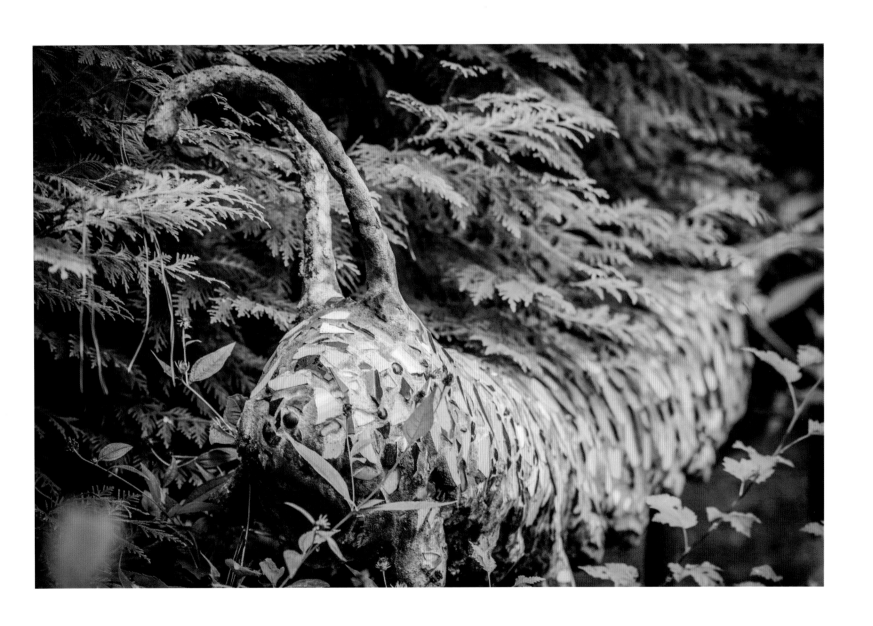

*Mayo Mac Boggs (1942-2014) was born and raised in Ashland, Kentucky. From 1970-2013, he was the professor of sculpture at Converse College. In 2010, he was honored by Converse College, Wofford College, and USC Upstate with a 40-year retrospective exhibition on each of the three campuses, featuring more than 300 pieces of his work. In 2013, he received the Elizabeth O'Neill Verner Governor's Award for the Arts. Boggs is best known for his metal sculptures in steel, stainless steel, and bronze.*

# MAC BOGGS
## *Alliance*

Carolina Alliance Bank, 200 South Church Street

The welded steel sculpture has remained a constant as my medium of expression. I love the look, feel, taste, smell, and sound of steel. My great-grandfather was a blacksmith in Kentucky; both my grandfathers and my father were welders and steelworkers. I grew up watching steel pouring from the blast furnaces and the nightly spectacular display of slag being dumped from huge, railroad-sized crucibles. I walked the railroad tracks and picked up scrap metal that had fallen from freight cars. The ironworker's material and process were an everyday part of my childhood in Ashland, Kentucky. I have taken this material and its process and made art, continuing a family tradition of ironwork.

—MAC BOGGS

Mac was a huge proponent of public art within a community. He especially believed that communities should purchase and exhibit the art of their own local artists. He wanted *Alliance* to represent Carolina Alliance Bank. The 16 birds represent the 16 founding directors. The sculpture also incorporates elements of the bank's logo.

—ANSLEY BOGGS, WIFE OF MAC BOGGS

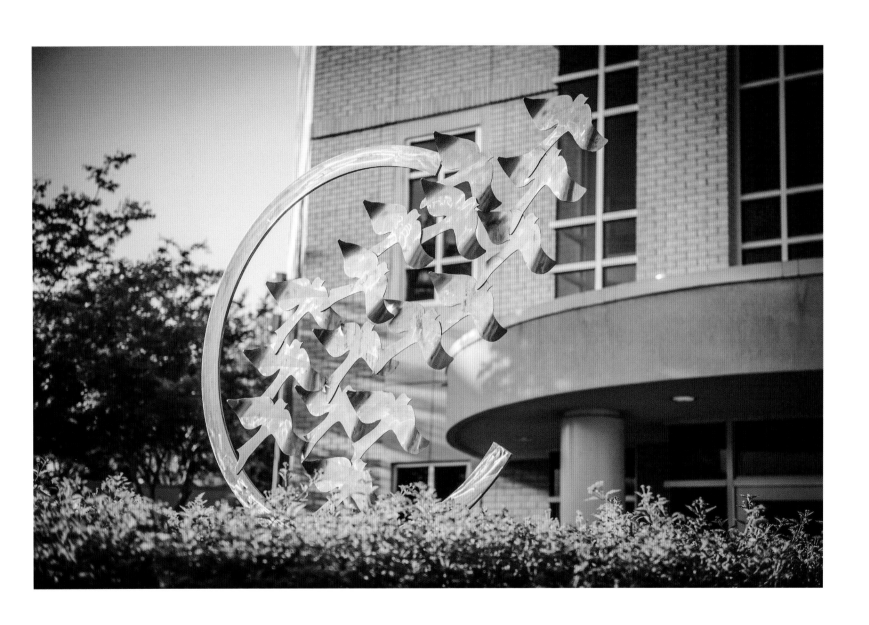

# HOONDIRT
## *Good-Bye Cruel World*
Hub City Art Park, West Henry Street

*Hoondirt (Cody Roberts) was born in New Jersey and moved to Spartanburg in 1989 at age 15. He admits to caring little for school and failing an art class because drawing and painting were never his forte. Growing up as a skateboarder was enlightening for him because the music and fashion "warped [his] brain for the better." His work has been installed and displayed at the Facebook Data Center in Forest City, North Carolina, the Spartanburg Downtown Memorial Airport, and Converse College. His greatest pride is his role as a single dad to his two boys, Farron and Drayk, who he says are, by far, his greatest creations.*

*Good-Bye Cruel World* won Spartanburg's Artcycle contest in 2013. The rules called for using recycled bicycle parts. As with all my pieces, I just start making stuff. I will fold some steel, and the piece really does create itself. When it starts taking shape, you just go with it. My friend Stephen Long gave me an old radio, and that really let me know this would be a robot. That became his mouth.

Originally, the robot was sitting on a bike in Morgan Square and his eyes would light up. The balloons are made out of bike rims. He's an extension of me—the mood of all my pieces mirrors my own.

He's content with just floating away. At the end of the competition, the city bought it and moved it into the Hub City Art Park, where another one of my pieces is located. I hope one day that place will be the Hoondirt Art Park!

When I have been in communities without public art, I think, "Yikes! No culture, no pulse! I'm glad I'm just passing through." I hope that my work allows people to have a different attitude towards Spartanburg.

—HOONDIRT

# CHRISTOPHER CROWLEY & NICK RING
## *The Conversion of St. Paul*
St. Paul the Apostle Catholic Parish, 290 East Main Street

*One of six siblings, Chris Crowley was born in Spartanburg in 1956 and lived a normal, small-town, Southern life. He attended St. Paul the Apostle Catholic School, Spartanburg Day School, and Hampden-Sydney College in Farmville, Virginia. The artistic gene runs very strong in his family: his brother, James Crowley, is a well-known portrait artist, and his uncle, George McClancy (1930-2014), was a pioneer abstract painter in the SoHo district of Manhattan.*

*Nick Ring is an award-winning commission artist working in a variety of sculpture, painting, and drawing mediums. He also explores glass painting and furniture design. Since 1991, Nick has created major works for public, institutional, private, and sacred installations. He was invited to attend the New York Academy of Art in Manhattan, where he was recognized for his talent as a figurative sculptor and artist. Nick has cultivated his skills in the Western classical tradition.*

Twenty years ago, the congregation of my church was required to relocate services from our historic Dean Street church to the school gymnasium because of dramatic growth. It was then that we began our long effort to construct a new church. From the very beginning, a great deal of thought went into attempting to build the most beautiful church possible while maintaining a disciplined eye on expenses. Father Timothy Gahan, contractor Joe Lauer, and I spent years concentrating on keeping costs down. One of the means of economizing was to use, wherever possible, locally produced or, in some cases, parishioner art work. Aware of my interest in painting, Father Gahan, Joe, and the architect convinced me to attempt to produce a sculpture for the project.

I was reluctant at first because I had never attempted sculpting before. I met with Nick Ring, the sculptor whom we had contracted for the façade sculptures, and asked him if he would teach me the process of producing a limestone sculpture for the new church.

I worked closely with him while he created the statue of the Virgin Mary in order to learn the

process. After the completion of the statue of the Blessed Mother, I began work on a tympanum, which would be a relief sculpture above the front door of the church. We agreed that St. Paul should be the subject and that his conversion on the road to Damascus would be the most appropriate scene. I spent months researching and producing dozens of half-scale drawings for the design. Then I traveled to Ellettsville, Indiana, to begin work with Bybee Stone Company on the sculpture. I am very proud of this work and can scarcely believe that I was able to execute it successfully.

—CHRIS CROWLEY, *top photo*

The strength of these sculptures lies in the simplicity of the stone characters, which took many years of hard work and study to achieve. Successful public art contributes to a community's understanding of itself and maybe a bit of the mysterious universe as well. It should resonate with the general public in a meaningful way.

—NICK RING, *bottom photos*

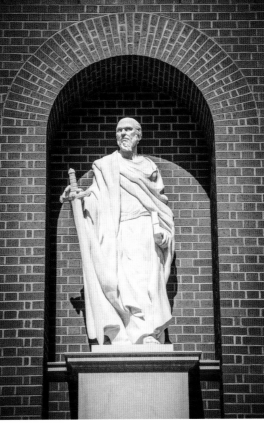

# RON LONGSDORF
## *Pacolet River Flood Memorial*
3061 US Route 29, Converse

*A former HUB-BUB artist-in-residence, Ron Longsdorf received an MFA in sculpture from the University of Delaware in Newark and a BFA in sculpture from the Pennsylvania State University in State College. His style melds traditional with experimental, video and audio aspects, and incorporates unique materials such as drywall, insulation foam, and found furniture. He has exhibited throughout the United States, as well as in Berlin, Germany, and Limassol, Cyprus. He teaches art at Kutztown University in Kutztown, Pennsylvania.*

While some people may feel disconnected to art displayed in galleries or museums, public art confronts the viewer and is far more accessible. This accessibility, as well as its ability to educate, gives public art the power to make the world a much more exciting place.

The Pacolet River Flood Memorial educates the public on the impact of the worst flood in South Carolina history, a disaster which devastated the Pacolet valley in 1903, destroying homes and textile mills and taking dozens of lives. The smokestack form and the height directly connect to the site and its history. The scale of the sculpture acts as a rough estimate of the water level at the flood's crest.

During the unveiling of the memorial, people were shocked by the sheer verticality of the sculpture. When the viewer stands next to it and peers up, they can imagine the immense volume of water that rushed through the area. The form itself is not solid; it is crafted from mesh to act as this ghost-like figure in memory of the event and the people lost during the flood. The mesh also provides a sense of permanence to the structure with minimal material; water could easily pass through the form without overpowering it, as the flood did to so many mills, structures, and people. I love that the memorial offers a short journey for viewers, as they quietly contemplate the historical event and walk down to the Pacolet River nearby.

—RON LONGSDORF

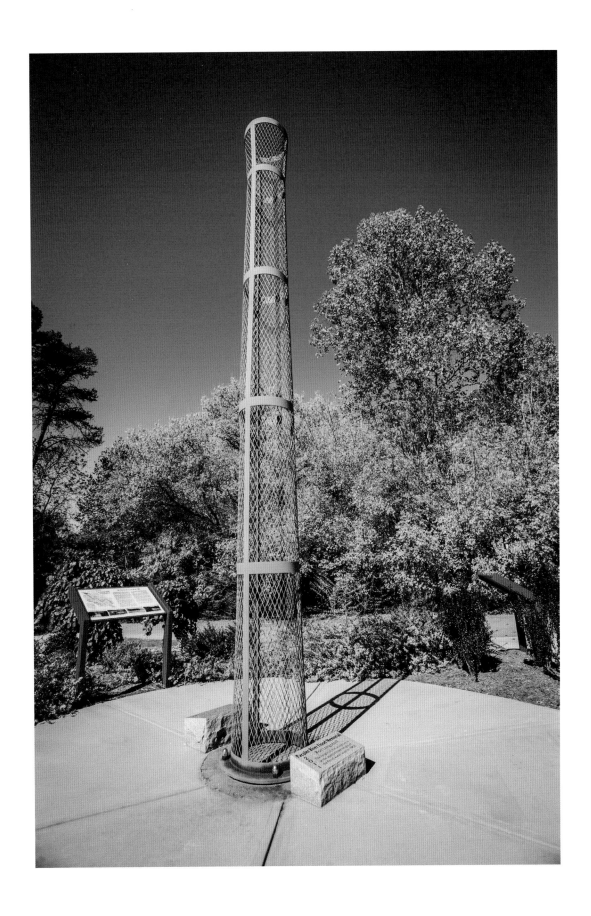

## DAINGERFIELD ASHTON
## *Toes Tulips*

Willow Oaks Park, West Hampton Avenue

*A native of Alexandria, Virginia, Daingerfield Ashton (1945–2015) taught art at the Spartanburg Day School for thirty years. After receiving an MFA in sculpture and printmaking at Winthrop University in Rock Hill, he taught art classes at Wingate University in Wingate, North Carolina, for eight years.*

Back in the mid-1990s, I wrote a grant to the National Endowment for the Arts to fund a summer of graduate work at Converse College to work with Professor Mac Boggs and to have an exhibition of the work I produced. Writing that grant was pretty elaborate, and the staff of the Spartanburg Arts Council—Cassandra Baker, Bill Taylor, and Ava Hughes—helped me to write the proposal. Cassandra was always vivacious and fun, and she was a great spokesperson for the arts in Spartanburg.

Mac turned the studio over to me. I went around town and bought all kinds of materials. I offered to give one of the pieces to the Arts Center on Spring Street. Cassandra picked this piece for their permanent collection, and it was installed in front of the Arts Center next to the big tree.

That summer was part of the impetus to go get my MFA at Winthrop University. At that time, I was doing a lot of found art, and people at Winthrop said, "We want you pretty much to start all over again."

A lot of the sculptures I produced that summer in Spartanburg went into private collections. I was selling them by the pound, and I had a scale to weigh them on—$1.23 a pound. It was cheaper than hamburger and it lasts a lot longer! *Toes Tulips* was moved to Hampton Heights when the Arts Center became a charter school. The Hampton Heights community wanted it to stay in the neighborhood.

—DAINGERFIELD ASHTON

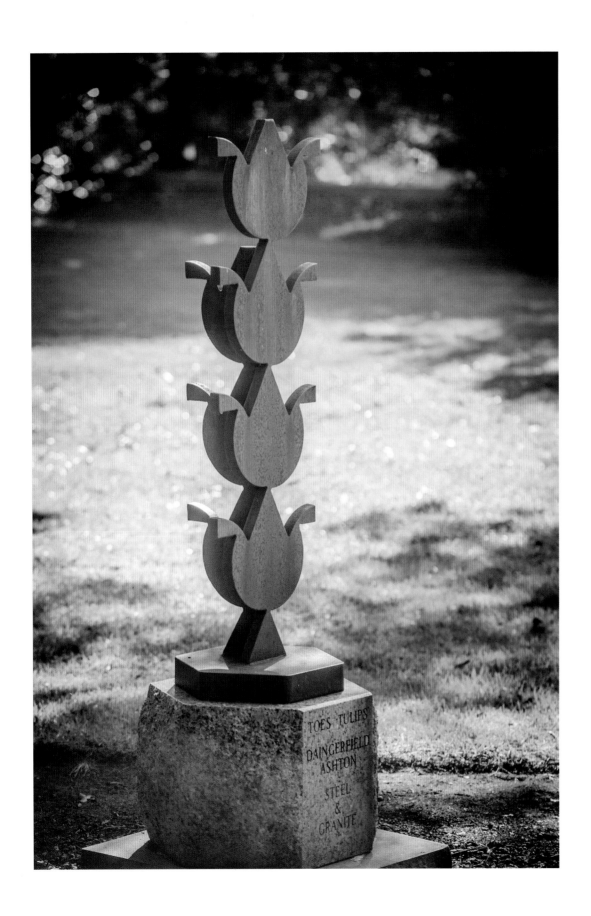

*Ishmael is a Spanish-born artist currently residing in Asheville, North Carolina. After reading the award-winning novel* Ishmael *by Daniel Quinn, he adopted the name in 1998 to further spread the messages contained within its pages. His murals can be seen in cities across the United States, including Detroit, Michigan; Miami, Florida; Jacksonville, Florida; Atlanta, Georgia; Washington, D.C., and New York.*

*Yamabushi, a painter who has lived in Asheville, North Carolina, since the 1990s, has a collage-like style that pulls from record albums, posters, and vintage advertising.*

*Russell Bannan is a public artist living in Spartanburg.*

# ISHMAEL & YAMABUSHI
## *Beyond Civilization*

HUB-BUB Studio Warehouse, 149 South Daniel Morgan Avenue

We wanted to create a locally-driven mural that was both funded and produced by the community. The artist Ishmael has strong roots here—he spent summers in Spartanburg as he was growing up. We launched a Kickstarter campaign with the goal of raising $2,000. We ended up with $2,600 donated by people from all over the world. One of the first gifts came from Daniel Quinn, the author of the book, *Ishmael,* who sent $500 and now has a picture of this mural in his office in Texas.

We had more than 20 people's hands touch the mural during the painting, ranging from age six to 60. The whole process was inspiring. To see the support for public art in our own neighborhood was very moving.

— RUSSELL BANNAN, PROJECT COORDINATOR

Public art reminds the community that magic and craft exist. The action of creation in the public space inspires locals and visitors of all ages to create as well. A community that showcases creativity cultivates creativity.

—ISHMAEL

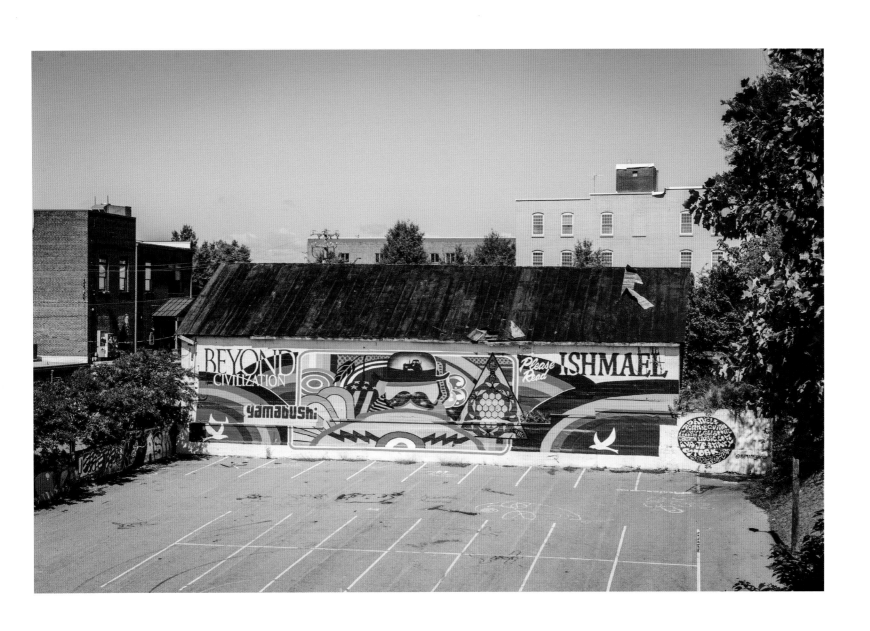

# HAROLD KRISEL
## *Trident Fountain*
Wofford College, Thomas B. Butler Circle

*Harold Krisel (1920-1995) studied architecture in Chicago, Illinois, at the New Bauhaus from 1946-1949 on the GI Bill after he was discharged from the army. He painted the bold, modernist murals at the Greenville-Spartanburg International Airport, which graced the walls there for decades, and also designed carpets and tapestries at Milliken & Company headquarters. Krisel's work is in permanent collections of the Metropolitan Museum of Art, the Museum of Modern Art, the Whitney Museum of American Art, and the Solomon R. Guggenheim Museum, all in New York City; the Smithsonian American Art Museum in Washington, D.C.; the British Museum in London, England; and Bibliothèque Nationale in Paris, France.*

When Wofford College was planning to build a new administrative building and alumni center on the North Church Street end of campus, several college officials realized that they needed to attract attention to the building's surroundings. The building, given by alumnus and trustee Dr. C. N. "Gus" Papadopoulos in honor of his father, Neofytos D. Papadopoulos, became something of Wofford's front door, and trustee Roger Milliken asked that the college "really think big in this area."

Milliken had known artist and sculptor Harold Krisel for some thirty years, and by July 1986, just a few months before the building was to open, Krisel presented several options for a sculpture or landscape feature near the new building. A Brooklyn native and former architect at Skidmore, Owings & Merrill, Krisel had designed the spray pond at Milliken's research center in Spartanburg.

Milliken had been one of Krisel's primary patrons over the years. In making a nod to Greek mythology and in tribute to the Papadopoulos family's Greek heritage, Krisel designed a fountain with three stainless steel circular shapes spraying water into a basin.

The fountain sits directly in front of the entrance to the Papadopoulos Building, surrounded by Butler Circle, named in memory of South Carolina Lieutenant Governor Thomas B. Butler (1903-1972). The fountain is positioned so that it is visible from the Cleveland Street entrance to campus as well as from the front door of the building. Roger Milliken and Sarah S. Butler, the wife of Thomas Butler, were the fountain and circle's donors.

—PHILLIP STONE, ARCHIVIST OF WOFFORD COLLEGE

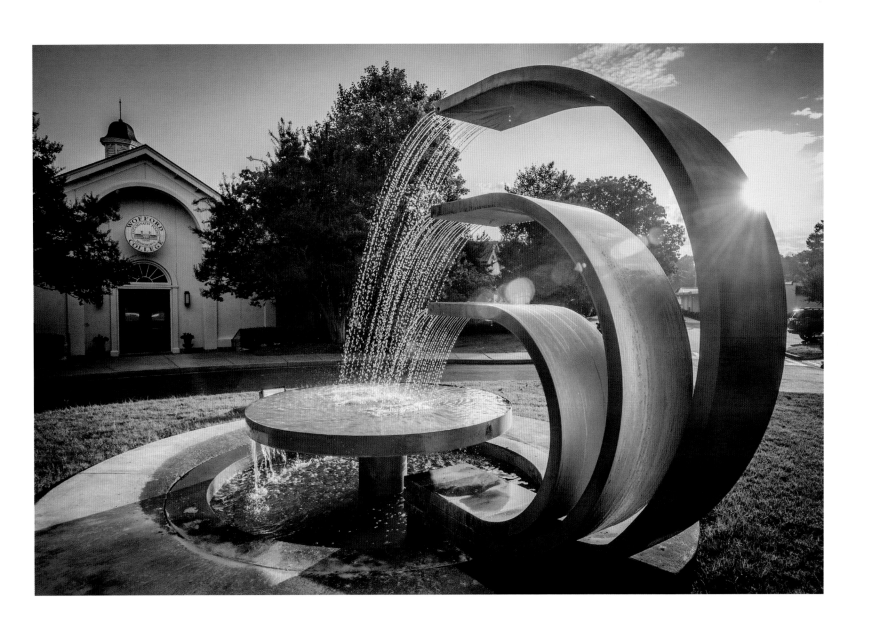

# ABE DUENAS
## *Turning Point Gate*

Cowpens National Battlefield, 4001 Chesnee Highway, Cowpens

*Abe Duenas is a California native who specializes in creating one-of-a-kind metal artwork. He works from a shop in Gaffney. Nature is often the common theme throughout his work. Abe has been commissioned to create pieces for many parks and celebrities. He is also an award-winning filmmaker, video editor, and photographer. He hopes to pass his knowledge on to his daughter, Sarai, one day.*

I think what makes the gate at Cowpens special is the story it tells. It is unusual to hear of stories where African Americans had an impact on the outcome of the Revolutionary War. But at Cowpens, where 15 black men fought with the Patriots, it is told that an African-American man may have saved the life of Colonel William Washington (1752-1810) during that famous battle. Several visitors to the park have told me how much they appreciate the gate and how it tells an unknown story. That's what every artist wants to do: tell a story with their work. Knowing that it is done every time someone looks at your work is huge.

I think public art plays an important part in our community, not because it provides work for artists, but because of how it can enrich our lives—even if a kid looks upon an artist's work and simply responds, "That's cool." However small the impact, it still is an impact.

My work has been inspired by my visits to the Metropolitan Museum of Art in New York City. That place is filled with so many creative works, not just paintings and sculptures, but any and every type of creative work that is worthy of being studied. Every time I visit, I take away something else and am inspired by something new.

—ABE DUENAS

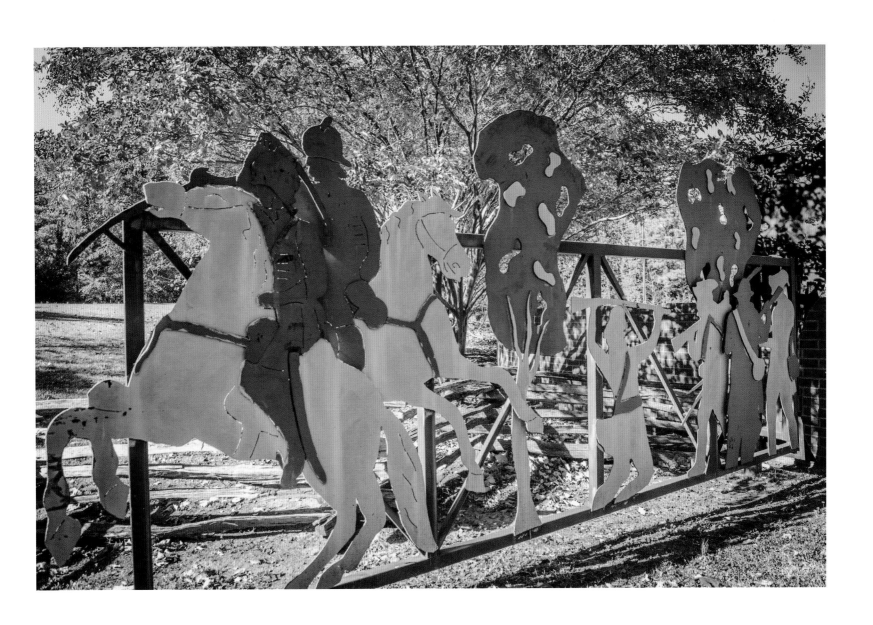

# RICHARD CONN
## *Trains on the Trail*

Mary Black Foundation Rail Trail, Corner of East Henry and Union Streets

*Richard Conn received his MFA in sculpture from Western Carolina University in Cullowhee, North Carolina. A former resident of the Landrum/ Tryon area, he now lives and works in Wilmington, North Carolina, where he teaches at Cape Fear Community College.*

In 2010, Partners for Active Living (PAL) received a grant from Women Giving for Spartanburg to commission a series of sculptures for the Mary Black Foundation Rail Trail to function as a focus for a scavenger hunt. This hunt would be directed at children, enticing them to make their way the entire length of the trail. PAL was looking for something that would link the current walking/biking trail with the history of the tracks and the trains that once operated there.

I wanted something that would appear lost in the woods, but also had an organic, indigenous feel. I discovered as I walked the trail that you could still find sections of the track back in the woods, rising up like old tree stumps or rotting vines. I decided to transform pieces of train rail into vine-like objects as if they had grown out of the ground organically. To these leafy rails, I added stylized, whimsical renditions of train engines, cars, and trolleys that had once run these tracks.

I torch-cut and forged the rail into five vine-like forms. I then added fused brass interpretations of the rolling stock to appear almost like flowers blossoming out of the vine. These were made to resemble a GE 44 Diesel Engine, the NW 611 Steam Engine, the Big 6 Trolley, the Glendale Trolley, and a Clinchfield Caboose. A local poet wrote a short story that gives hints about where to find the trains on the trail. Although they never found their way into the story, if you look closely at each of the sculptures, you will find depictions of my dogs.

The whole process took about six months, after which I was called back to produce a trailhead marker for the trail. This marker, which stands about nine feet tall at the Henry Street end of the trail, is cut from Corten steel and formed to reference both the industrial nature of the tracks and the organic character of their return to the earth. Within the sheaf of steel form, you can find the names of each of the trains on the trail.

—RICHARD CONN

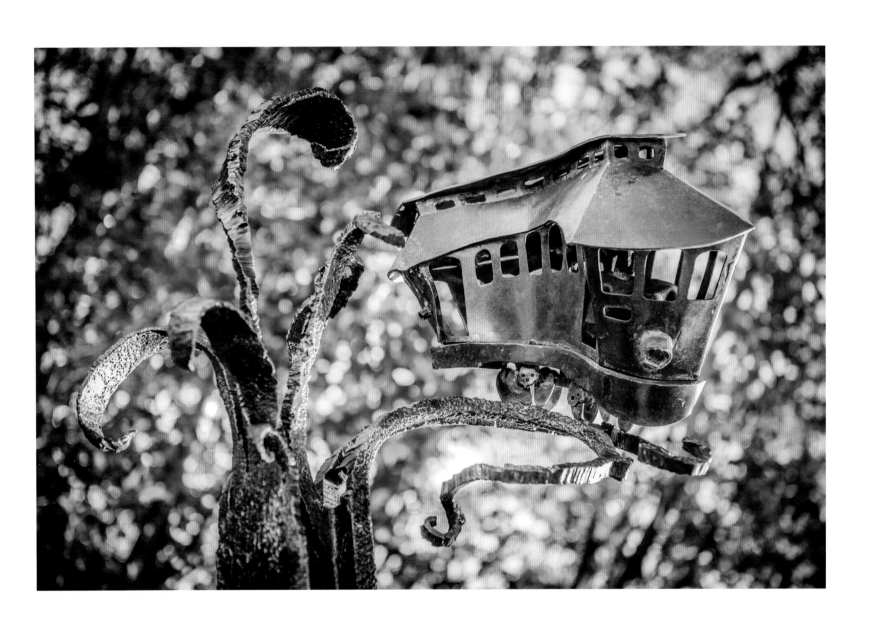

# BAILIE
## *Untitled*

Bike Worx, 1321 Union Street

*Over the past 15 years, Bailie has developed a successful career creating fine art, executing more than 500 murals regionally, and teaching art in workshops, classrooms, and private lessons. As owner of Bailie Studios in Spartanburg, he has become well known for his unique and varied style. Known only as Bailie, he has exhibited at Princeton Seminary Hall at Princeton University in Princeton, New Jersey, Greenville–Spartanburg International Airport Gallery, Converse College, USC Upstate, the North Charleston City Gallery, and many other places.*

To me, this mural is fun and colorful, which draws the viewer in. It features a character named Professor Alloy in a blimp. Conceptually I wanted something family-friendly to attract visitors to the Rail Trail and bring traffic to the Bike Worx business (win/win). I believe that tastefully done, public art enhances the community and shows a sense of cultural awareness to visitors. I had a huge canvas here, and the only requirement was that it be fun. I love those types of jobs!

My work has been shaped by having the privilege of working and studying with my mentor, the late Thomas Parham, for eight years. I not only learned how to create murals, but I absorbed his vast knowledge of life and art. Perspective and vision are my most important tools.

What's the most memorable response I've had to this piece? "You did that? That's freakin' awesome!"

—BAILIE

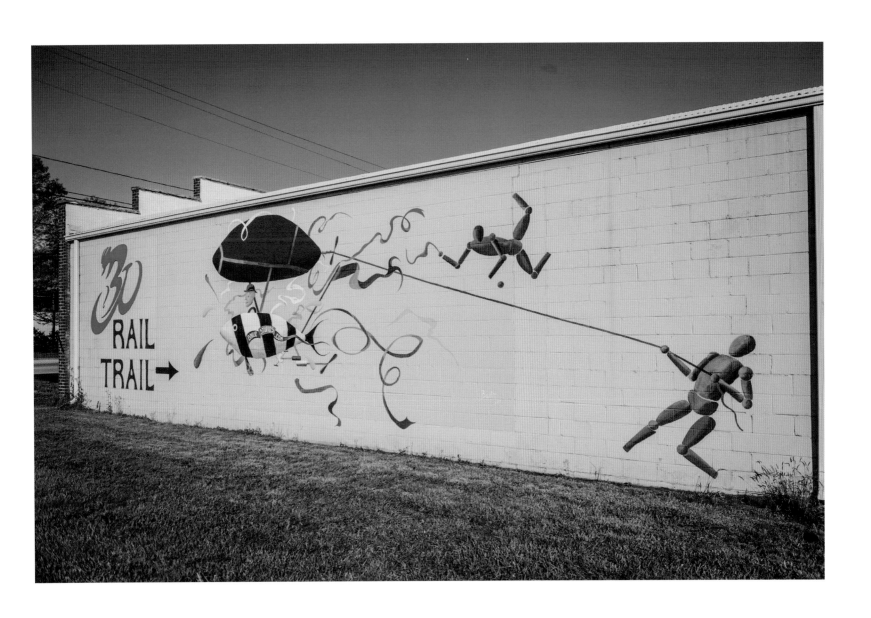

# BERRY BATE
## *Rebirth*

Parking loop on Emma Cudd Road off Whitestone-Glendale Road, Glendale

*Berry Bate is a graduate of Converse College who has created more than 2,000 pieces of sculpture and ironworks for private residences, collectors, public places, and colleges during her 35-year art career. She has created work for the Biltmore Estate, the Billy Graham Training Center at the Cove, and the Grove Park Inn, all in Asheville, North Carolina, as well as Chimney Rock State Park and many other places. She also served as a consultant on the restoration of the Statue of Liberty. She is the founder of Asheville Ironworks and operates Sculpture by Berry Bate in Asheville.*

In 1999, I was commissioned by the Glendale community and the Hub City Writers Project to do a sculpture for the community of Glendale and Lawson's Fork Creek. Residents were putting a lot of effort into restoring their homes and cleaning up the river in hopes of creating an important recreation area. I was asked to focus on the feeling of rejuvenation and hope and decided to do a piece that would be the entrance to the community and would stand out proudly at 13 feet tall.

I realized that the umbrella magnolia was indigenous to the area, so I made six-foot-long leaves representing the plant. This was quite a feat to forge, since it was like putting a surfboard into the forge. You can imagine the smoke that was created. The top of *Rebirth* is a blossom, just unfolding—like the community. The center has 16 elements like flames, to give a feeling of energy to the area.

I believe that public art is a spokesman for the community. The residents look at it inquisitively, thinking, "What is it trying to say?" Art has a great power and is a needed statement of originality and joy in each city.

—BERRY BATE

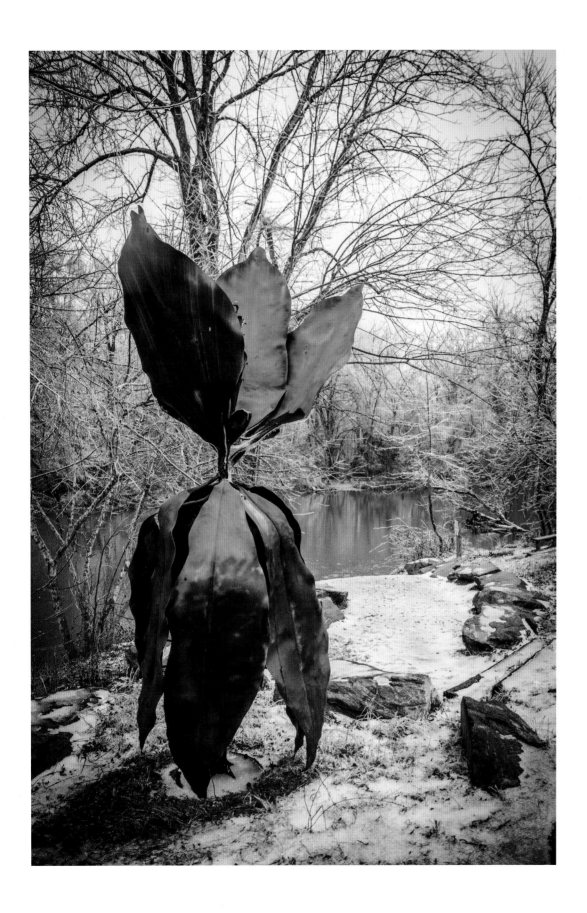

*A native of California now living in Belgrade, Montana, Jim Dolan is known for his Western wildlife in bronze, copper, and steel, ranging from tabletop size to a golden eagle with 36-foot wingspan installed in Osaka, Japan. He has created more than 170 large-scale public pieces worldwide, as well as scores of private works. He also created six-foot-tall blue heron sculptures for the Gibbs Cancer Center at Spartanburg Medical Center.*

# JIM DOLAN
# *Unity*

Spartanburg Area Chamber of Commerce, corner of East Saint John and North Pine Streets

The story of *Unity* goes back to 1977 when Roger Milliken saw my Canadian geese installed in the Bozeman, Montana, airport. Through his architect, Mr. Milliken said he wanted geese just like those for the Greenville-Spartanburg International Airport. I said, "You want something unique," and so we settled on the snow geese that are in the airport now. That was my introduction to Spartanburg.

There is a charitable society known as the Group of 100 in Spartanburg that commissioned the globe as one of their early projects to recognize the international people and companies. In Bozeman, I had done a globe made of 28,000 pennies. *Unity* is made out of something like 15,000 stainless steel washers. Washers have holes in the center so the light comes through. If you get up close to it, you can see that I built up the mountain ranges to give it some contour.

—JIM DOLAN

# MARK WHITE / LYMAN WHITAKER

## Wind Ripples /
## Double Dancer and Double Helix Sail

305 North Church Street

*Mark White grew up in Centralia, Illinois. He received his BA in sociology from Southern Illinois University in Carbondale. In addition to the meditative and mesmerizing kinetic wind sculptures for which he is so well known, White is a prodigious painter. He works in many mediums, including engravings on metal, oil on panel, and oil on metal. His studio is in Santa Fe, New Mexico.*

*Lyman Whitaker has been a practicing sculptor for more than 50 years. From his studio in southern Utah, he focuses on the creation of wind sculptures, kinetic art that responds to the changing currents of the wind. His sculptures are installed all over the world—in museums, at the seaside, in urban areas, in public venues, and backyards.*

This piece has the ability to capture literal movement as well as implied movement. I was influenced by my children, one of whom is a professional ballerina. Movement, and especially dance, imparts my kinetic wind sculptures with indelible energy and dynamism. People have been very responsive to my work, and many say my sculptures help them relax and unwind, and that they have meditative qualities.

My creation process is serendipitous, following a certain line of experimentation without clinging to a known hypothesis. This process guides my art in many directions, including work with engraved patina paintings as well as wind-and-water-driven kinetic sculptures. I love learning and am always exploring my artistic boundaries, searching for the path less traveled.

—MARK WHITE

A kinetic sculpture needs to be responsive to the most gentle breeze and yet able to withstand strong winds. Balance and bearings are the answer to the first need, and the second need is answered in the way in which I fabricate the piece to give it strength. These elements are important so that the wind will propel my sculptures in a balanced fashion, which makes them responsive yet under control. The materials I choose are copper for its malleability and color, and stainless steel for its strength. Both these materials do well outside in the elements.

The two Spartanburg sculptures work in unison to generate a dynamic interplay of shapes. Each design permits the sculpture to be responsive in different ways to the currents of the wind, allowing ever-changing forms to emerge. The effect is both mesmerizing and invigorating.

—LYMAN WHITAKER

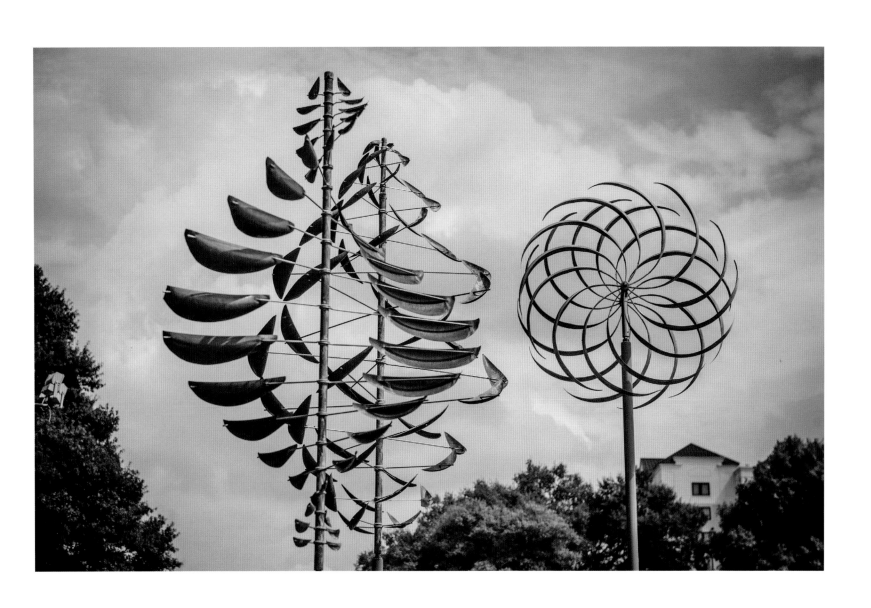

# AMBER HANSEN & LORENZO TEASLEY
## *Northside Community Garden Mural*
Brawley Street

*Amber Hansen came to Spartanburg from Kansas as a HUB-BUB artist-in-residence. She actively exhibits in the mediums of film, drawing, and musical performance and has been the lead artist on many public murals located throughout the Midwest. She was the lead assistant to artist David Loewenstein on community-based mural projects in Tonkawa, Oklahoma (2010), Joplin, Missouri (2011), and Hastings, Nebraska (2013). She is the co-director and co-editor of* Called to Walls, *a documentary film about creating community-based murals in the Midwest.*

*Garrett Lorenzo Teasley II, a former resident of Fremont School Apartments on the Northside, is the founder and innovator of #AGEOLD, a community arts organization in Spartanburg. He describes himself as "just a brother in Christ looking to invest back into the community."*

The strength of this piece lies within the people who came together to create it. Lorenzo and I spent over a month meeting with Northside neighborhood residents, kids at after-school programs, and students at Cleveland Academy of Leadership to collect the imagery and ideas that were then woven into the narrative of the mural.

When meeting with the students at Cleveland Academy, I asked this question: "If you had a garden, and you could plant anything in the garden, what would you grow?" In response to this prompt, many strange plants were imagined: some growing basketballs, other plants producing iPods, music, cars, and money. Many of these drawings can be found in the mural, as well as poems, songs, and quotes that were suggested by participants.

Public art can be a great benefit to communities, especially when the community has a voice in the shaping of the work or a hand in making it.

—AMBER HANSEN

The benefit of public art within the community is that it provides aesthetic interest and provokes an emotion that can't be replaced. Communities that are distressed need it the most. The people in these communities see nothing but poverty, crime, and struggle, but public art provides a reprieve and breath of fresh air. It gives them something beautiful to adore and something to connect to and to see themselves in. Public art brings sweetness to the soul and connects us all.

—LORENZO TEASLEY

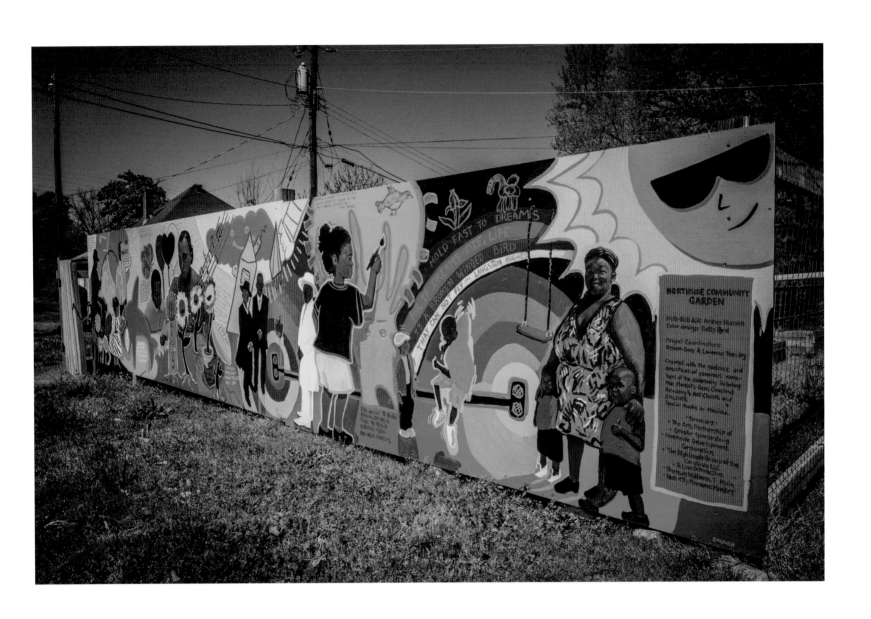

# DENNIS SMITH
## *Skip Rope*

Landrum Public Library, 111 East Asbury Drive, Landrum

*For the past 40 years, Dennis Smith's work and presence have been a driving force in sculpture in the United States. His representations of families, mothers, and children in sculpture have become a national treasure. His work is located in hundreds of public and private collections, in museums, and public squares throughout the world, including the town center of Vail, Colorado; the Children's Hospital in New Orleans, Louisiana; and the San Antonio (Texas) Zoo. His impressionistic style captures his exuberance for life and embodies his passion for transcendence—expressed through the spontaneity of children, reflections of the past, and hopes for the future. Smith lives and works in Alpine, Utah.*

Visually, this piece has a lightness about it. The figure is floating as if it were off the ground, mid-skip. Its energy is airborne, recalling the carefree nature of childhood. The symbolism of the piece is represented by the skipping of the rope, which implies the passage of time. The challenge of childhood is to do more skips in a row than the last time, to improve your time, to give more effort, and to do it again, only better.

My high school English teacher, Mr. Washburn, inspired me. He would stand in the front of the class and recite poetry with tears in his eyes.

He helped me see the importance of creating expression and infected me with the passion to create.

When a piece "works," it is a tremendous fulfillment. But when other people express that same feeling—that it has done something for them or moved them emotionally—it is so rewarding. There is so much of yourself in the thing that you have created that it is all that much more special when it is loved by someone else.

—DENNIS SMITH

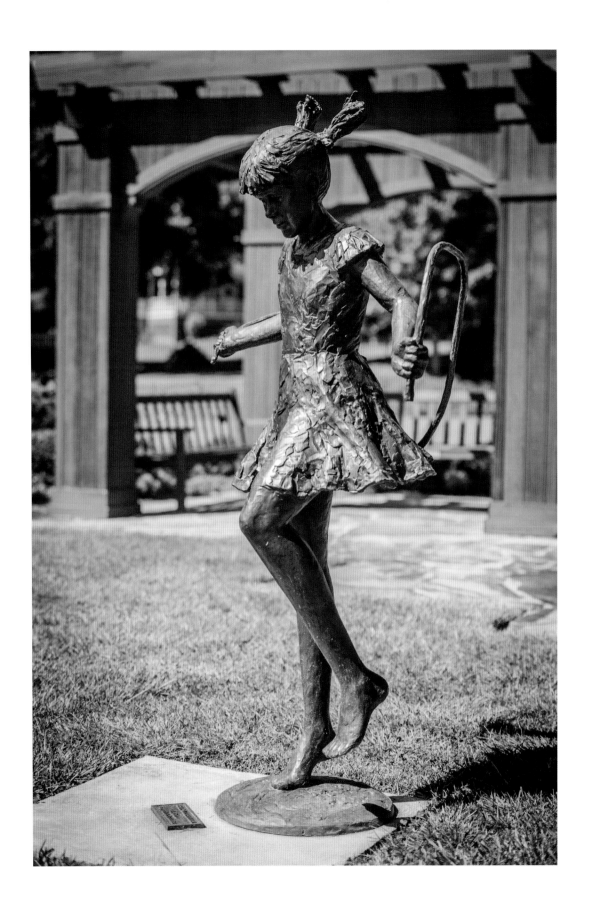

# BRANDI CRISCITIELLO
## *Untitled #77*
South Carolina School for the Deaf and the Blind, Thackston Hall

*Brandi Criscitiello was born and raised in eastern North Carolina. As a child, she enjoyed time in the garage with her father, helping him work on old cars and motorcycles. It was during her childhood that she developed a passion for design through cars and motorcycles and a love for the coast. Since earning a BFA in studio art with a concentration in photography and sculpture, she has moved back to the coast, a place that inspires her the most. Today, she teaches art at White Oak High School in Jacksonville, North Carolina, and is an artist in her free time.*

The specific moment that shaped the direction of my life took place during my sophomore year at Converse College when I decided to take my first drawing class since high school. Teresa Prater was my professor, and I specifically remember her asking me what my major was. I said, "I'm not sure." She responded to me, "Well, I think you should do art." This simple interaction between student and professor set me on a path that has led me to where I am today.

*Untitled #77*, a piece that was completed through a sculpture class at Converse, was my first large-scale kinetic piece. I wanted it to look streamlined, fast, and clean. Additionally, I wanted it to resemble a rail dragster with the back heavier than the front, given the large rear tires. Placing the fulcrum at a perfect point allows the larger end of the piece to pivot upwards as easily as the front does. I felt this gave the piece a unique look and concept, allowing a person to change the movement of the "car" by a touch of the finger.

It's a great honor to have this piece at the South Carolina School for the Deaf and the Blind. I have received awards for photography and painting, but the best feeling is the moment of overwhelming satisfaction and contentment after completing a piece that you are truly proud of.

—BRANDI CRISCITIELLO

## BOB DOSTER
# *Untitled Portal*

University of South Carolina Upstate, Center Quad

*Bob Doster lives and works in Lancaster, South Carolina, where he operates Backstreet Studio. During a 30-year teaching career, he taught pottery and sculpture to an estimated 120,000 public school children in South Carolina. In 2006, he won the Elizabeth O'Neill Verner Governor's Award for the Arts, the highest award given to individual artists in South Carolina. Hundreds of his pieces are in public and private collections, including a 65-foot interior piece at the University of North Carolina in Chapel Hill and a 40-foot piece at Saks Fifth Avenue in Atlanta, Georgia.*

*Untitled Portal* is part of a series of portals ranging in size from 12 inches to over 10 feet. The idea of portals came from science fiction books I have read over the years. I believe that art, like time-space portals, transcends time—from its creation in the past to the present and onward for future generations. I am making a portal from the past to the future.

I made one of these, then somebody bought it, and I thought I'd explore the theme further. All my work since grad school had started as scrap, but when I began this series, I had to start making my own scrap. I use a plasma cutter to cut out the pieces, then I fold them into the center of the ring, and I weld them and overlap them in a way that you don't see the weld. Jane Nodine at USC Upstate asked me to do a show there in 2008, and I had enough pieces of that size.

While the portal sculptures make up a small vein in my body of work, almost all of my sculptures have their origins in discarded shapes. I like to explore static movement in the sculpture I create. It is a frozen moment in time and a quick glance into the mind of an artist at work.

—BOB DOSTER

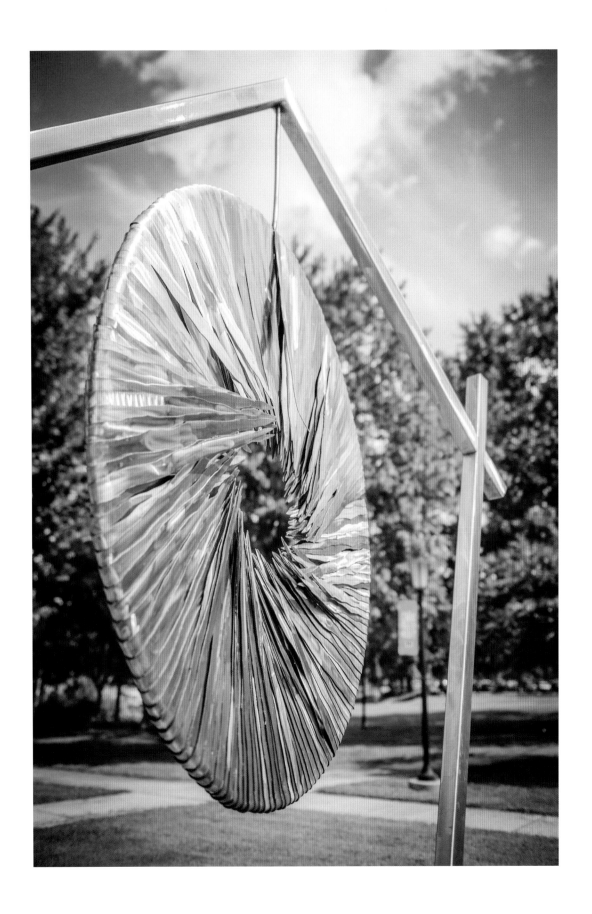

## LEE WILKIE
## *Untitled*

Hot Spot Skate Park, 339 Union Street

*Born in Spartanburg, Lee Wilkie now lives in New York City, working as a creative director and designer for some of the world's largest fashion and performance companies. He is also an accomplished musician, having written songs for young rock-and-roll and R&B artists that have appeared on American music charts.*

A long time ago, I drove behind an old laundromat on the east side of Spartanburg and discovered a wall that one artist had begun to cover entirely on his own. That artist was Lucho Gomez, and his wall was once located on East Main Street. He showed me that art was something for me to give to the world.

For this piece commissioned by the Graffiti Foundation, the bold fields of color are what most people find inviting and easy to access. With murals, the location and who will see the work weigh heavily on the decisions that an artist makes regarding subject matter and message.

The benefits of these art projects in the city are endless. They encourage a feeling of togetherness and inclusion of all cultural influences in the area. Instead of fighting to find a place in the community, people can be integrated into the city by way of these art pieces. They broadcast the social health of the area. I always hope people will be blown away by some facet of the artwork.

—LEE WILKIE

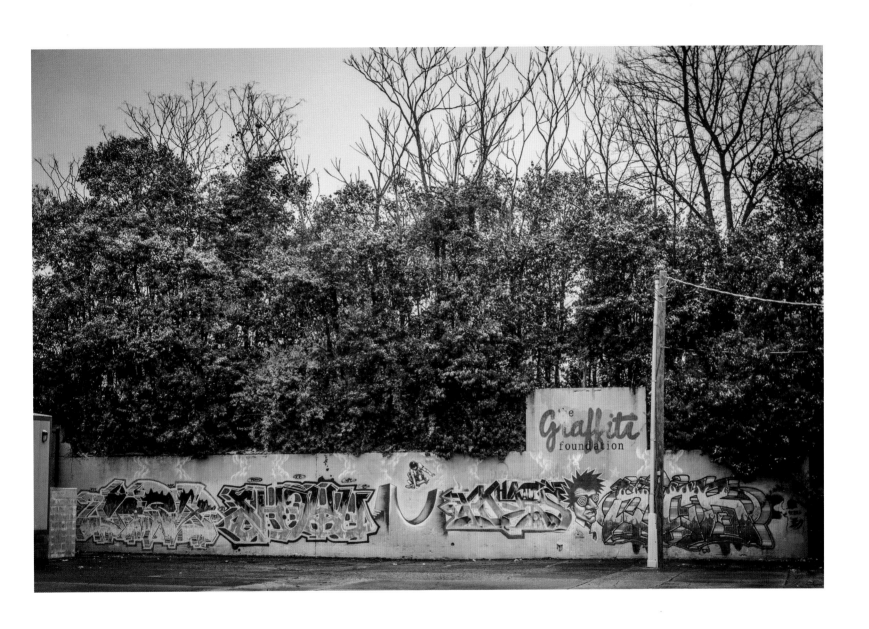

# GLENNA GOODACRE
## *Wall Street Journal*
One Morgan Square

*Born in Lubbock, Texas, in 1939, Glenna Goodacre is one of the United States' best-known living sculptors. Goodacre is most celebrated for creating the* Vietnam Women's Memorial *on the National Mall in Washington, D.C., a life-size bronze of President Ronald Reagan at the Reagan Library in Simi Valley, California, and the* Irish Memorial *for the city of Philadelphia, Pennsylvania. She also designed the millennium dollar coin featuring the image of Sacagawea and her infant son, Jean Baptiste Charbonneau. Glenna now lives in Santa Fe, New Mexico.*

*Wall Street Journal* is part of a larger piece called *Park Place*, so he is not site specific, but he adapts well to many different settings. The piece was an edition of 18, so they are all over the United States in collections, and there are two of them in Brazil! *Wall Street Journal* was very popular in New England.

My father believed in me as an artist. When I was a teenager, he took me to Europe for two months to look at the masters. It was life changing for me. In my work, I use the arms and legs in figures to create interesting design elements. Many of my public art pieces, especially the ones with children, have a lot of zigs and zags, parallels and diagonals to create visual interest. My favorite tool is a great big serrated kitchen knife. You see the marks of them on every large-scale work of mine. I get lots of fan mail about the big public pieces like the *Vietnam Women's Memorial* and the *Irish Memorial*.

I believe public art is invaluable for creating a sense of character for a community, areas of focus, gathering places, and landmarks.

—GLENNA GOODACRE

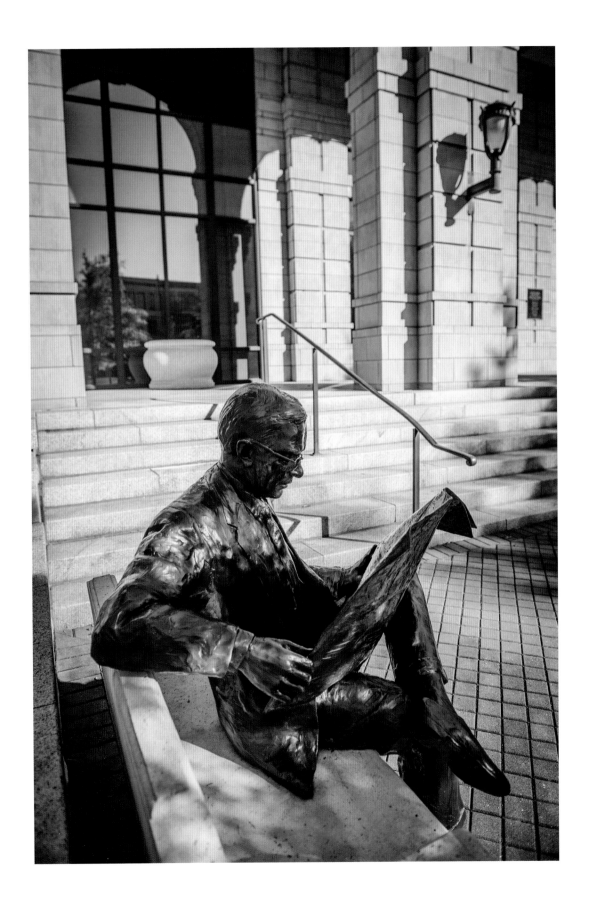

# BILL COBB, CHRIS COX, TIP PITTS & SCOTT PARRIS
## *Water Orb*
156 Magnolia Street

*Bill Cobb, chairman and chief executive officer of J M Smith Corporation, is a Spartanburg native, woodworker, and avid amateur musician whose commitment to a vibrant, beautiful downtown is based on "a simple truth: if you want people to come, you have to have a place they want to be." The downtown campus of the J M Smith Corporation, including its arboretum, is one result of that philosophy.*

We wanted to improve the appeal of our plaza between our corporate office and the Magnolia Street Parking Garage. While we were researching landscaping features, we came across a picture of a large sphere resting on the ground. It was made of polished stainless steel, and as soon as we saw it, we were hooked on the idea of bringing one to Spartanburg. It fit the plaza (and Spartanburg) beautifully with its modern look and feel, but also with a nod to the gazing balls that were popular in Victorian gardens.

It took over seven months to get the original ball delivered. The stainless steel ball was manufactured in China, shipped by freighter via the Panama Canal to New York, and then trucked to Spartanburg. When the crate arrived, we were very excited—until we saw that a forklift had punctured the crate and the ball. So we were back to waiting for a new ball. As the container ship approached New York Harbor, Hurricane Sandy came up the coast, forcing the ship out to sea. As a result, the ship lost its docking spot and was delayed for over a month.

One positive thing to come out of the wait was the inspiration to turn the ball into a fountain. We constructed a stand with a hollow core and welded the ball to it. During the construction of the QS/1 building in 2003, we had recovered granite bricks and bench slabs, which we decided to use to construct the pool at the bottom of the fountain and seating around the fountain. When the ball finally arrived, it was installed on a Saturday in January when the high was 18 degrees, so the installation was memorable from beginning to end!

Many people take their pictures in front of the sculpture. On sunny days, it is a favorite place for people working in nearby offices to enjoy their brown-bag lunch. During cold spells, it seems to be a favorite shot for area photojournalists working on a "beautiful frozen fountain" piece. Some people toss coins in it for a wish.

—BILL COBB

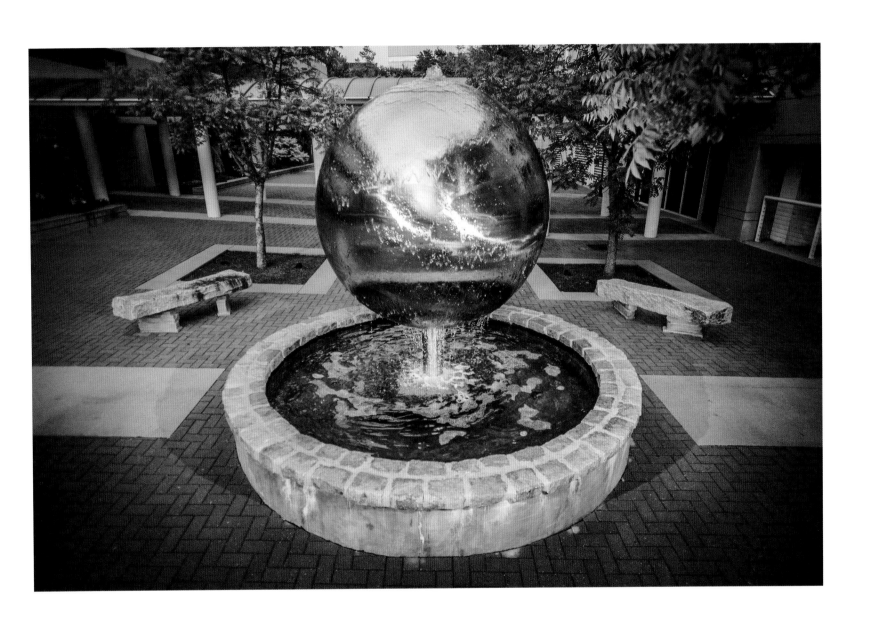

**HUB CITY PRESS**

THE JOHNSON COLLECTION

Hub City Press is an independent press in Spartanburg, South Carolina, that publishes well-crafted, high-quality works by new and established authors, with an emphasis on the Southern experience. We are committed to high-caliber novels, short stories, poetry, plays, memoir, and works emphasizing regional culture and history. We are particularly interested in books with a strong sense of place.  Hub City Press is an imprint of the non-profit Hub City Writers Project, founded in 1995 to foster a sense of community through the literary arts. Our metaphor of organization purposely looks backward to the nineteenth century when Spartanburg was known as the "hub city," a place where railroads converged and departed.

Located in Spartanburg, South Carolina, the Johnson Collection offers an extensive survey of artistic activity in the American South from the late eighteenth century to the present day. The Johnson family is committed to creating a collection which captures and illuminates the rich history and diverse cultures of the region. By making masterworks from its holdings available for critical exhibitions and academic research, the collection hopes to advance interest in the dynamic role that the art of the South plays in the larger context of American art and to contribute to the canon of art historical literature. The collection also seeks to enrich its local community by inviting the public to interact with these inspiring works of art.

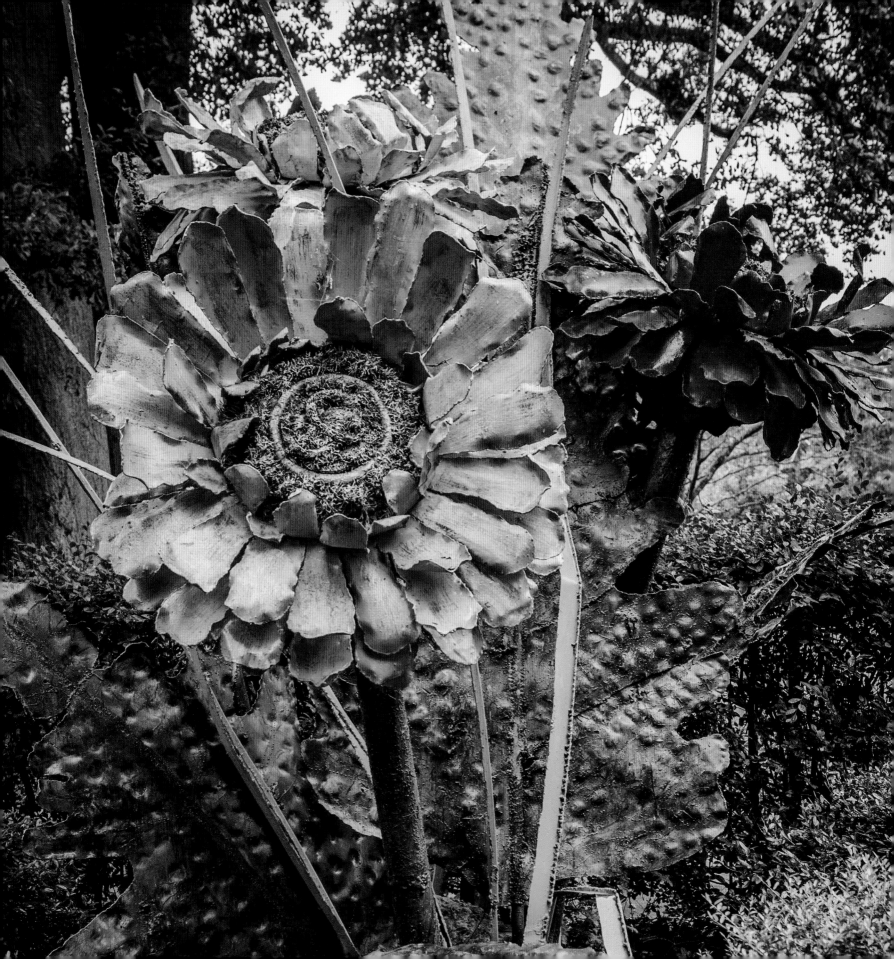